YEOVIL
THROUGH TIME
Robin Ansell & Jack Sweet

AMBERLEY PUBLISHING

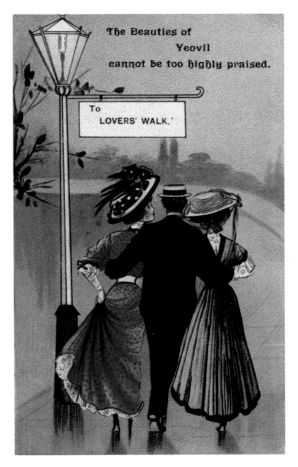

The Beauties of
Yeovil
cannot be too highly praised.

To
LOVERS' WALK.'

Yeovil novelty postcard, *c.* 1905.

First published 2009

Amberley Publishing Plc
Cirencester Road, Chalford,
Stroud, Gloucestershire, GL6 8PE

www.amberley-books.com

Copyright © Robin Ansell & Jack Sweet, 2009

Every effort has been made to contact copyright
holders. In the unlikely event that you have been
overlooked, please get in touch so the appropriate
credit can be included in future editions.

The right of Robin Ansell & Jack Sweet to be
identified as the Authors of this work has been
asserted in accordance with the Copyrights, Designs
and Patents Act 1988.

ISBN 978 1 84868 603 8

British Library Cataloguing in Publication Data.
A catalogue record for this book is available from
the British Library.

Typeset in 9.5pt on 12pt Celeste.
Typesetting by Amberley Publishing.
Printed in the UK.

Contents

Acknowledgements

The authors would like to express their appreciation to the following individuals and organisations, who materially assisted in the compilation of this book:

Allan Collier, Roger Grimley, Derek Phillips and Mike Shorter
AgustaWestland, South Somerset District Council and Yeovil Library.

(Yet again, the patience and forbearance of our respective spouses,
Bernie Ansell and Margaret Sweet, is acknowledged with grateful thanks.)

All the matching digital colour photographs (except the one appearing on page 58),
were taken by co-author Jack Sweet, during 2009.

Front cover illustration: The Borough looking east, *c.*1907 (see pages 10-11)

*This book is affectionately dedicated to the memory of the
'doyen of Yeovil local historians'.*

Leslie Ernest John Brooke (1914-2003)

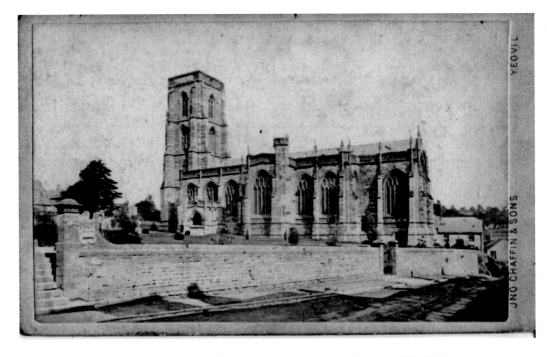

Parish church of St John the Baptist, Silver Street, *c.* 1875 — carte-de-visite (Chaffin).

Introduction

Picture Postcards (1894 – present)

The majority of the historic images in this book, have been reproduced from the J. W. Sweet Postcard Collection. Such topographical postcards were first given approval by the Post Office in 1894. Five years later a standard size of 5.5 x 3.5 inches (13.9 x 8.8 cm) was adopted. These early postcards were designed with the image (plus any correspondence) on the front — only the addressee's details being permitted on the back. In 1902, the 'divided-back' postcard was introduced, the design which remains in common use today. Both message and addressee are on the same side of the postcard, usually 'divided' by a vertical line. The most popular image subjects on (franked) postcards were topographical in nature, though the same format was used extensively for portraits — numerous examples being found in early-twentieth-century family photograph albums.

Before the advent of modern communications technology, the humble postcard was the 'texting' of its day. With frequent and speedy postal deliveries the norm, postcard messages could be sent, and arrive on the same day! During the 'Golden Age' of postcard-sending (*c.* 1900 – *c.* 1918), more than 7 million were delivered in a single year! Though essentially ephemeral items, thankfully many have survived the ravages of time to become valuable historical social documents.

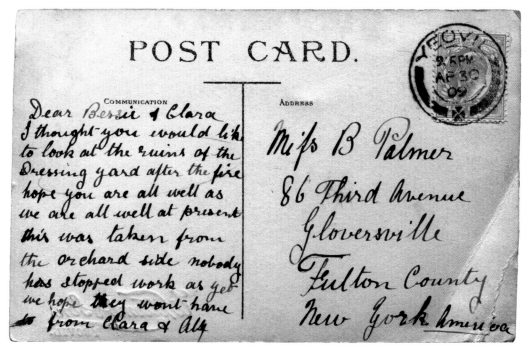

Mill Lane Fire, 23 April 1909 — postmarked only a week after the tragic event! (see Disasters [page 88] for further details and front image of postcard).

Dating 'tips':
- 'Undivided-back' – 1894-1901
- 'Divided-back' – 1902 to the present
- Postage stamp – if present, denomination and monarch can provide dating clues
- Postmark – if legible, provides 'not after' date
- Photographer/printer/publisher – if given, can provide dating clues (consult local trade directories and/or postcard reference books)
- Image subject matter – buildings / transport / fashions can provide dating clues
- Correspondence – if present, can (sometimes) be highly informative (see example on page 5)

Cartes-de-visite (*c.* 1860 – *c.* 1900) and Cabinet Cards/Prints (*c.* 1866 – *c.* 1910)

The predecessors of the postcard format are the less-well-known, but equally important, carte-de-visite and its larger counterpart, the cabinet card/print. Patented in France, in 1854, by the Parisian photographer Andre Adolphe Eugene Disderi, cartes were introduced into Britain about 1860. They derived their name from their similarity in size to the conventional visiting (or calling) card (4 x 2.5 inches/10.2 x 6.4 cm) – a purpose for which they were rarely, if ever, used. Popularised by the royal families of both Britain and France, the sitting for, and collecting of, such cartes swiftly reached epidemic proportions – this 'Golden Age' (*c.* 1860 – *c.* 1870) being dubbed 'cartomania'!

To cope with the public's insatiable demand for 'photographic likenesses, the number of studios grew dramatically during this period. In London alone, 'photographic artists' increased from 160 in 1861 to almost 300 five years later. Many provincial towns witnessed

Carte-de-visite, *c.* 1865.

Cabinet card/print, *c.* 1870.

a similar growth, though by contrast Yeovil experienced what can only be described as a volatile stagnation! In 1861 there were just two studios: Swatridge on Princes Street and Treble on Sherborne Road. Five years later there were still only two, but a different two: Francis on Princes Street and Chaffin on Hendford. A studio might produce up to 80,000 cartes in a single year, consequently the total national output could easily have run into hundreds of millions!

Special family photograph albums were produced in which to store and organise this superabundance of cartes. Queen Victoria herself is known to have owned over a hundred such albums. The photographs were inserted into pre-cut apertures (usually one, two or four to a page), typical subjects being: family, friends, celebrities (including members of the royal family, statesmen, high-ranking officers of the army and navy, religious leaders, actors and actresses – and topographical views).

Such topographical cartes would often depict country houses, parish churches and tourist attractions. In the latter category, abbeys, cathedrals, castles, seaside resorts and spa towns were popular – with the occasional local street scene. Album images would invariably exhibit a common thread running through them, one of close familial associations. Though not as numerous as portrait cartes-de-visite (nor the later postcards), surviving topographical cartes remain an important part of the visual historical record. See the rare local examples, on page 4 & page 8).

An enlarged version of the carte-de-visite, the cabinet card/print (6.5 x 4.5 inches/16.5 x 11.4 cm), was introduced about 1866 – being far better suited to broader topographical subjects. However, both formats were eventually to disappear, with the growing popularity of the picture postcard, in the early years of the twentieth century.

Carte-de-visite, *c.* 1875.

Cabinet card/print, *c.* 1883.

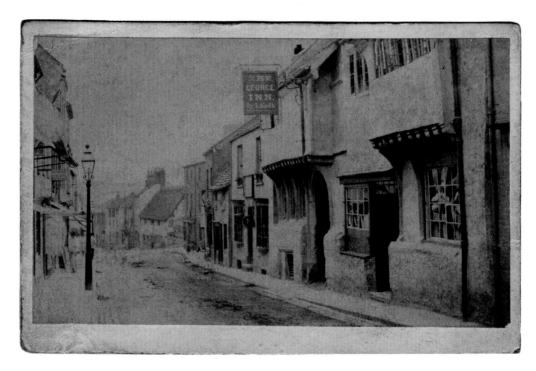

The George Inn, Middle Street, *c.* 1872 — carte-de-visite (Gosney?)

Dating techniques, for both cartes and cabinets, are similar to those outlined previously for postcards – with the notable exceptions of correspondence and postal information. (See the examples from the Yeovil studio of John Chaffin, on pages 6-7).

Dating 'tips':
- Carte-de-visite – *c.* 1860-*c.* 1900
- Cabinet card/print – *c.* 1866-*c.* 1910
- Photographer – if given, can provide dating clues (consult local trade directories and/or *The PhotoHistorian*: *Professional Photographer Supplements*, published by the Royal Photographic Society [Historical Group])
- Image subject matter – buildings/transport/fashions can provide dating clues
- Exhibition prize medal(s) – provides a 'not before' date
- Square-cornered card mount – *c.* 1860-*c.* 1870
- Round-cornered card mount – *c.* 1870-*c.* 1910
- Simple photographer's advertisement – *c.* 1860-*c.* 1870
- Elaborate photographer's advertisement – *c.* 1870-*c.* 1900
- Pale coloured card mount – *c.* 1860-*c.* 1890
- Dark coloured card mount – *c.* 1890-*c.* 1900
- Bevelled edge – *c.* 1880-*c.* 1910
- Gold/silver lettering – *c.* 1890-*c.* 1900

Robin Ansell and Jack Sweet, October 2009

chapter 1
Street Scenes

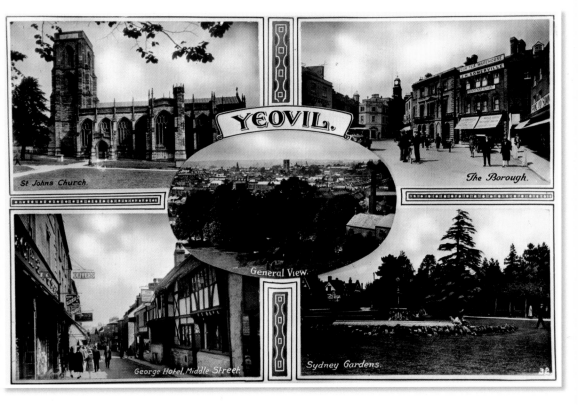

Yeovil multi-view postcard, *c.* 1925.

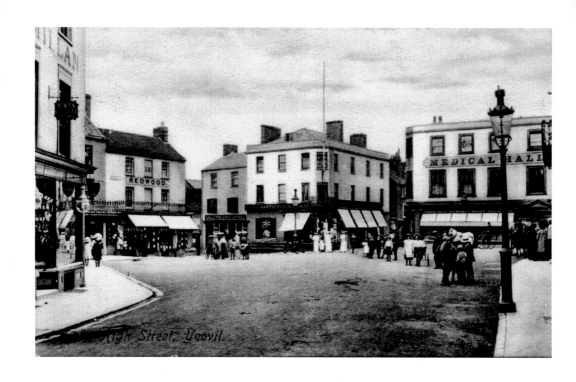

High Street, Yeovil.

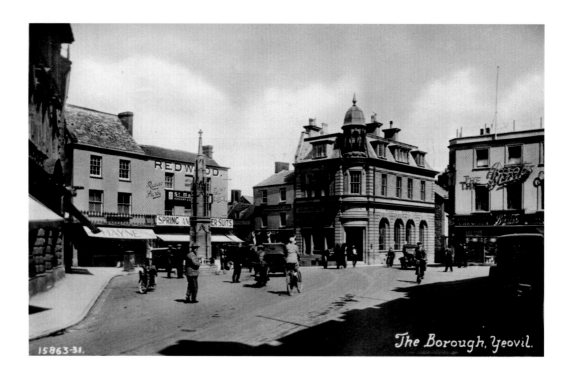

The Borough, Yeovil.

15863-31.

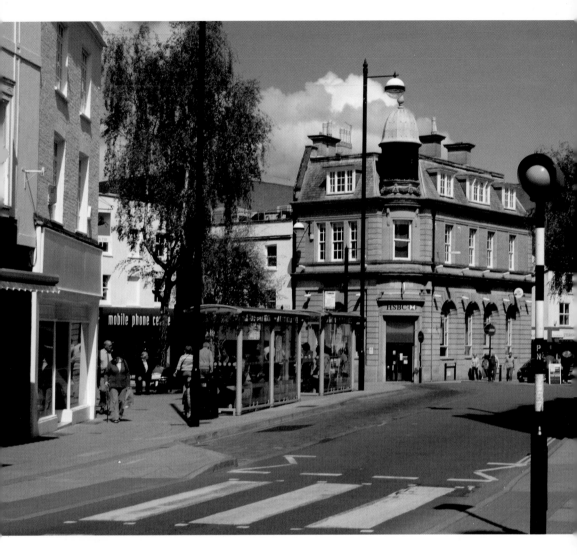

The Borough Looking East, *c.* 1907 and *c.* 1925

The Borough is the ancient heart of Yeovil, going back to the town's Saxon beginnings over a thousand years ago, and yet it actually forms part of the postal address of the High Street. The postcard at the top of page 10, sent in 1907, shows the Borough in one of its quieter moments, but in the lower postcard from the 1920s this scene has changed with the bustle of motor vehicles and cyclists and by the impressive Midland Bank (now HSBC), built in 1914. A more poignant note is the war memorial standing prominently on the left. It records the names of the 236 Yeovil men who fell in the First World War (1914-1918), and to which has been added the names of 118 servicemen and civilians from the town who lost their lives in the Second World War (1939-1945) and one serviceman who died in the Falklands conflict of 1982. The modern photograph shows the Borough changed dramatically by the street furniture, trees, the covered bus stop and pedestrian area. The Medical Hall, subsequently Boots, was destroyed by a German bomb on the night of Good Friday 1941, rebuilt in 1956 and is now a Burger King fast-food restaurant.

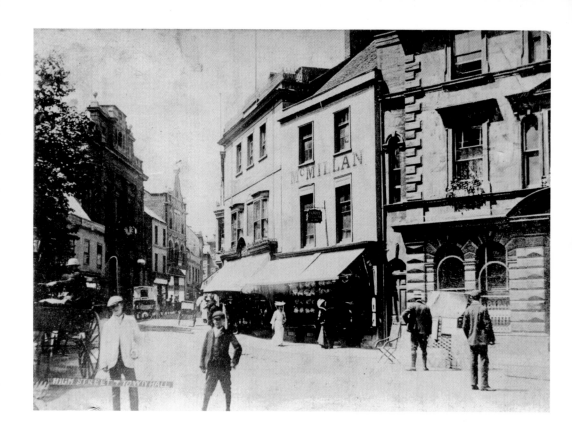

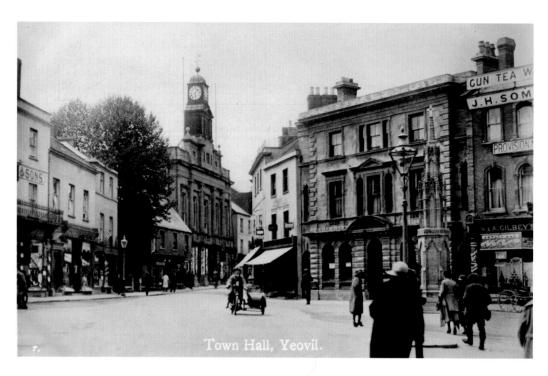

Town Hall, Yeovil.

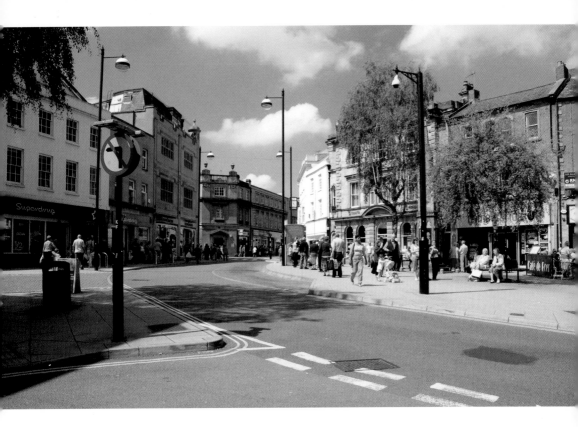

The Borough Looking West, *c.* 1905 and *c.* 1925

The two postcards on page 12 were taken twenty years apart, the top in 1905, the one below in 1925, and there are two notable differences. In 1905, the large building on the left is the town hall (built 1849) and by 1925 it is crowned by an impressive clock tower, the gift of Thomas William Dampier and his sister to commemorate the coronation of George V in 1911. Once again the war memorial is a prominent feature. In the modern photograph, apart from the white Regency building occupied by Superdrug, all the buildings on the left were built after 1926 and around the war memorial the Borough has been transformed into a pleasant pedestrian area, with trees, seats and a pavement café atmosphere.

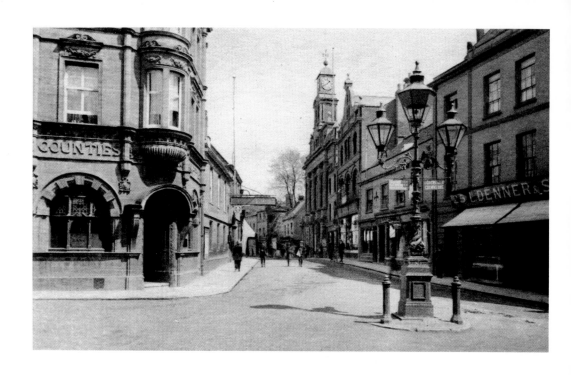

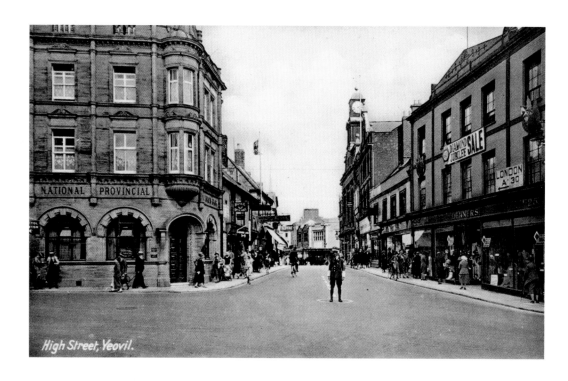

High Street, Yeovil.

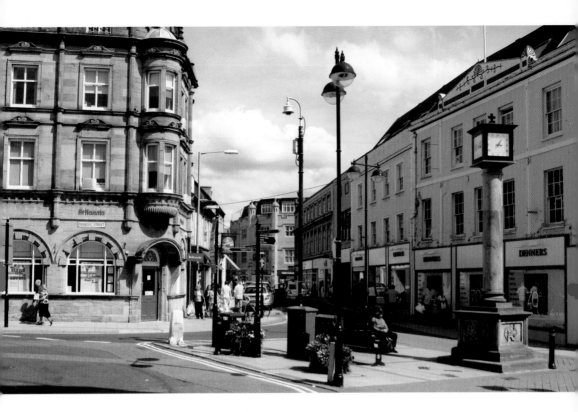

High Street Looking East, *c.* 1912 and *c.* 1935

Three pictures of High Street from 1912, 1935 and the present have some common features. Firstly, the street is the same width, secondly; the building on the left continues to provide financial services, as it was formerly a bank and is now the Britannia Building Society; and, thirdly, Denners department store, opened by Linsey Denner at 25 High Street in 1875, is now owned by J. E. Beale plc but continues in business as Denners. The prominent clock tower caught fire on 22 September 1935 and the resulting blaze destroyed the town hall. The large Sugg gas lamp, standing at the entrance to High Street in 1912, was removed in 1928, and, in its place in 1935, an RAC patrolman directs traffic from a white circle painted on the main A30 London Road. AD 2000 was celebrated by the erection of the Millennium clock, designed by local historian the late Leslie Brooke.

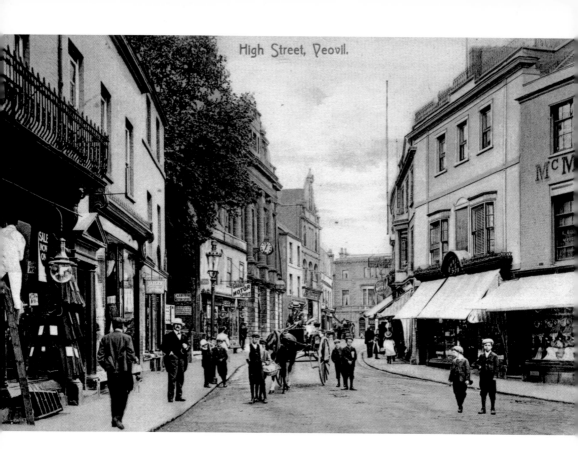

High Street, Yeovil.

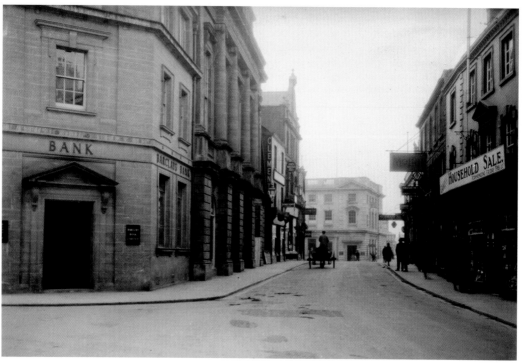

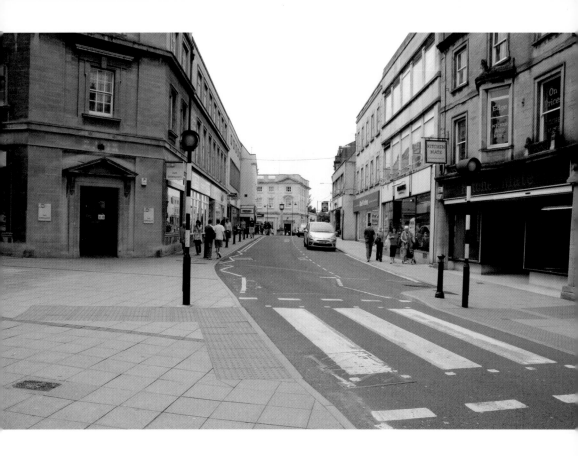

High Street Looking West, *c.* 1907 and *c.* 1931

The colourful postcard of High Street was posted in 1907 and a closer look reveals a glimpse of the future under the clock where a sign advertises a garage and motor spirit. On the left, a 'shopman' hangs clothes outside Damon's outfitters, a common practise by shopkeepers but imagine the scramble when it began to rain! The second photograph can be dated by the advertisement of Gamis's 'Household Sale' commencing Friday 20 February in 1931 and shows an almost deserted High Street. Beyond Barclay's bank is the town hall and then Clement's stores with its prominent roof line. In the new photograph, Totesport now occupies the old bank, the site of the town hall now accommodates the Borough Arcade, and Clement's shop was demolished in the 1960s and is now the site of the Argos store. Gamis' premises were rebuilt in 1933 and are now occupied by Denners.

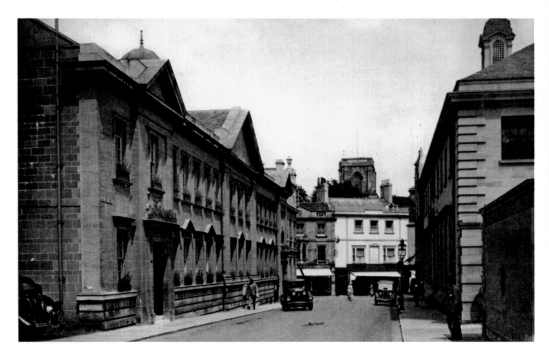

King George Street, *c.* 1935

The postcard of King George Street from the mid-1930s shows, on the left, the Yeovil Borough Council's 'New English Renaissance' municipal offices, library and museum opened in 1928, and opposite, the general post office built in 1932. Now traffic-free, King George Street with its trees and seats is a pleasant part of central Yeovil. Prominent in the precinct is John Fortnum's 1994 sculpture 'Jack the Treacle Eater' named after the well-known folly in Barwick Park, with images representing Yeovil's past, present and future.

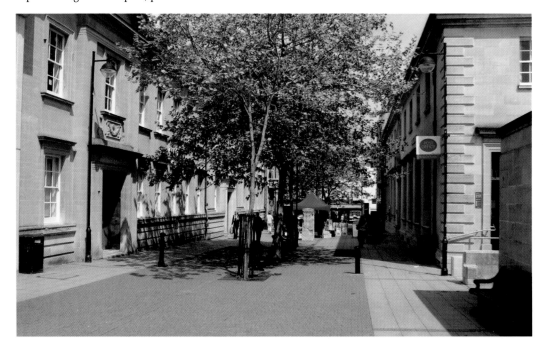

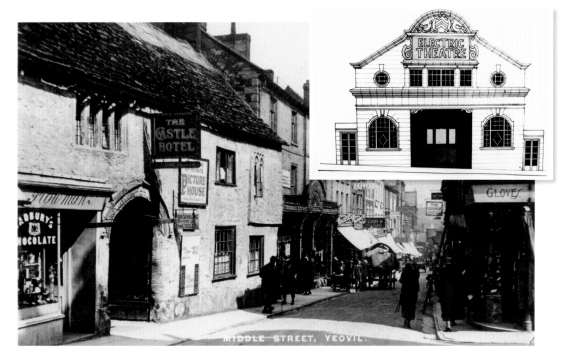

Middle Street Looking East, *c.* 1910 and 1919 (inset)

In 1919 it was proposed to build the Electric Theatre shown in the inset on the site of the ancient Castle Hotel. The plans never materialised, but the hotel succumbed to the Montague Burton chain of men's outfitters whose shop was destroyed by a German bomb in October 1940. The modern photograph sadly reflects the economic recession when Woolworths closed their store on 27 December 2008 (something which Hitler had failed to achieve!) and during the summer of 2009, the Birthdays and Party Land shop closed next door.

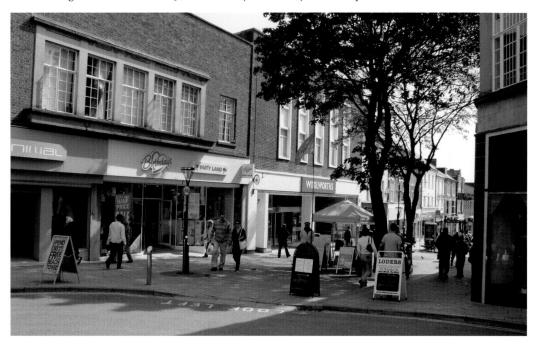

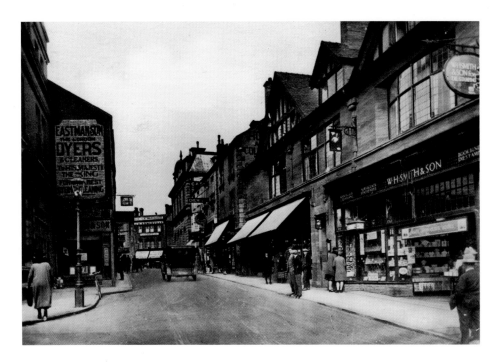

Middle Street Looking West, *c.* 1925

In this photograph from the 1920s, Messrs W. H. Smith's book shop is featured prominently on the right, and at the entrance was a large open counter for the sale of newspapers and magazines. In 1932, the general post office, just off to the left, moved to King George Street and Marks & Spencer took over the premises. In the 1970s, a form of retail 'musical chairs' took place when Messrs Smith moved into Marks & Spencer's premises and Marks & Spencer moved to a new store across the road!

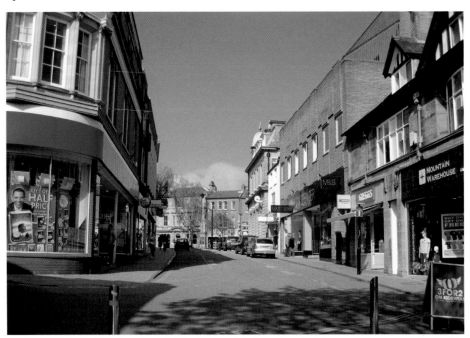

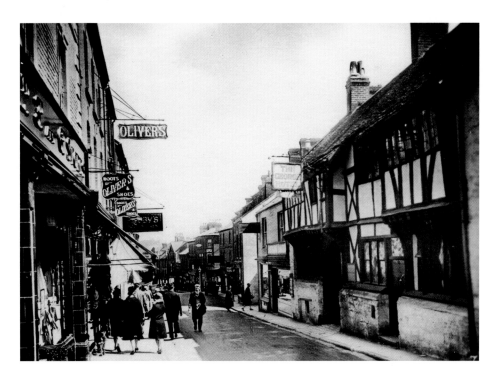

Middle Street and The George Inn Looking East, *c.* 1925

The photograph from the 1920s shows the George Inn as many people remember it and indicates how narrow this part of Middle Street was at the time. The increase in traffic during the nineteenth and early twentieth centuries had resulted in Middle Street being widened, but a bottleneck remained outside the George Inn. In 1962, following a public inquiry, the owners received permission to redevelop the site with shops and provide land for road widening. The George Inn was demolished, but within less than ten years this part of Middle Street was pedestrianised and has provided a source of debate ever since.

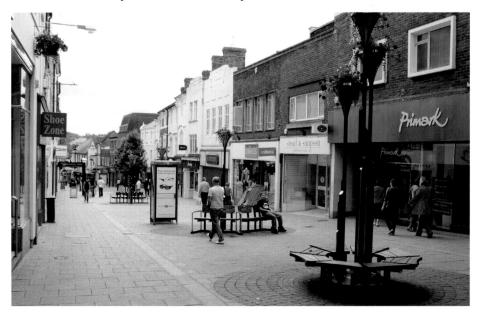

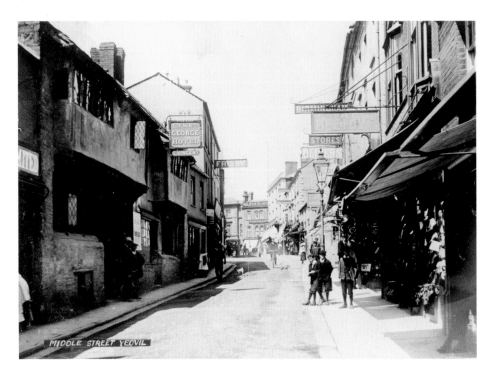

Middle Street and The George Inn Looking West, *c.* 1900

This postcard from a century ago once again emphasises how narrow Middle Street was outside the George Inn. It also shows the multitude of hanging signs and shop blinds which were such a feature of the time. Note the rather drab façade of the George. The modern photograph presents a rather pleasing street scene (the exception being the telephone kiosk) and it can be said with some justification that the pedestrianisation of Middle Street has been a success.

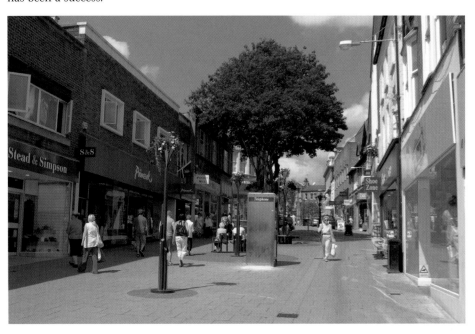

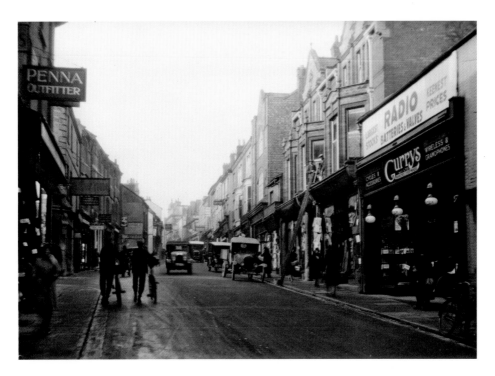

Middle Street and Curry's Looking West, 1930

The photograph of Middle Street taken in 1930 gives a fairly good impression of how four motor vehicles and a few cyclists could make the street look somewhat congested and, compared with the modern photograph, the shop fronts look cluttered. The two men perched on the first floor shop front with an unsupported and unguarded ladder standing in the gutter would doubtless fall foul of today's health and safety legislation!

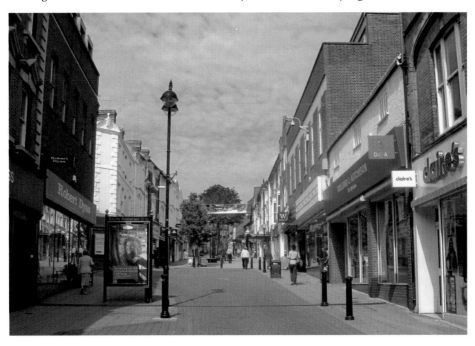

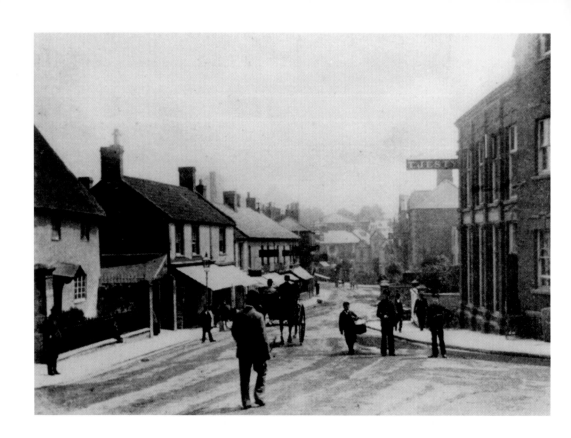

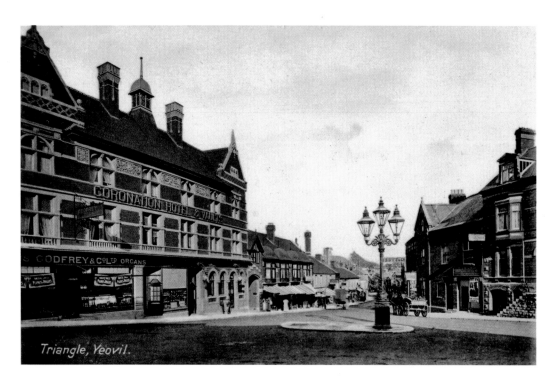

Triangle, Yeovil.

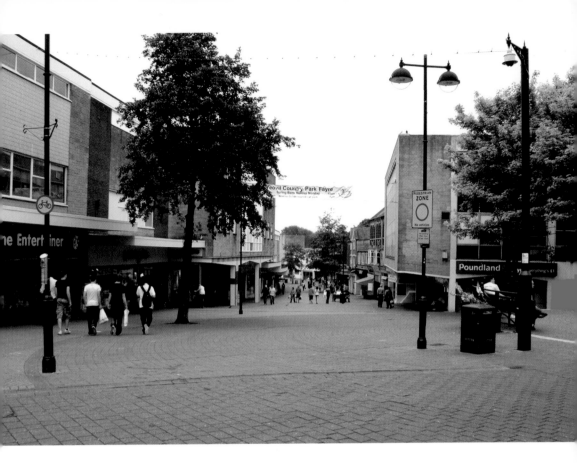

The Triangle Looking East, *c.* **1896 and** *c.* **1906**

The photograph at the top of page 24 was taken about 1896 from the Triangle and shows how this part of Middle Street was beginning to change. At the extreme left a cottage still remains with its small front garden, but, further down, the ground floors of houses have been converted into shops and on the right is Jesty's new furniture emporium. The lower colour postcard shows that within ten years the scene has changed again. The Coronation Hotel now dominates the area, the site of the cottage had been replaced by four new shops to the right of the hotel and a three-lantern Sugg gas lamp stands in the centre of the Triangle. The modern photograph shows a complete change, and although it might be suggested that some of the character of this part of Middle Street has been lost by the large-scale 1969 Glovers Walk retail development, the trees are a pleasant addition.

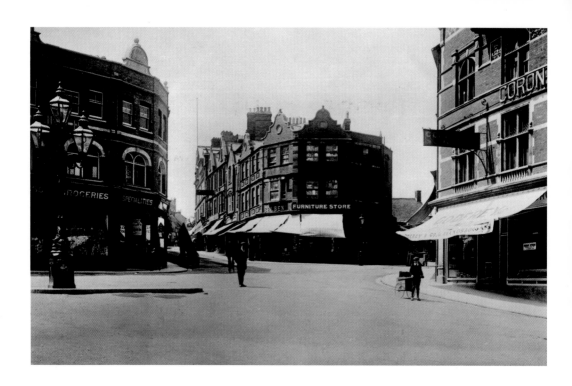

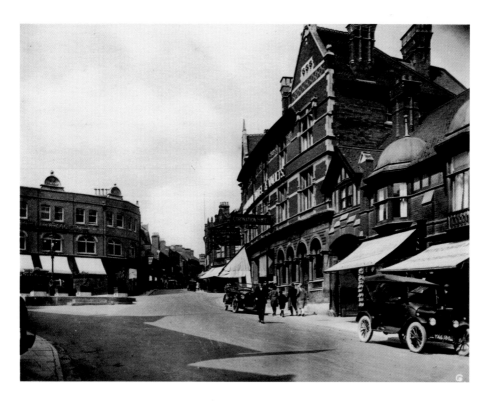

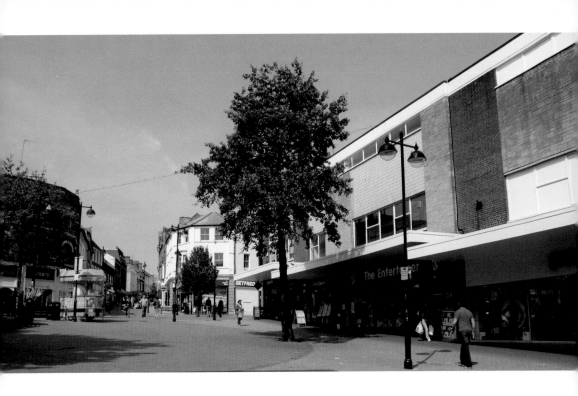

The Triangle Looking West, *c.* 1912 and *c.* 1925

The upper postcard on page 26 dates from about 1912 and shows three well-known Yeovil landmarks of the last century — the Yeovil Co-operative Central Stores (built 1910), Belben's Bazaar and furniture store in the centre and the Coronation Hotel. The Sugg lamp remains clearly visible and the sole representative of wheeled transport is the lad with his cart! When the lower photograph was taken in the mid-1920s, there were two notable changes: ladies' and gentlemen's underground public conveniences had been built where the lamp once stood and can be seen centre left and motor cars are present. In the modern photograph, just visible centre left by the yellow kiosk, is the open-air Entertainment Centre built on the site of the old conveniences, the Coronation has made way for shops, the Co-operative Central Stores and Belben's remain but with different occupiers and uses.

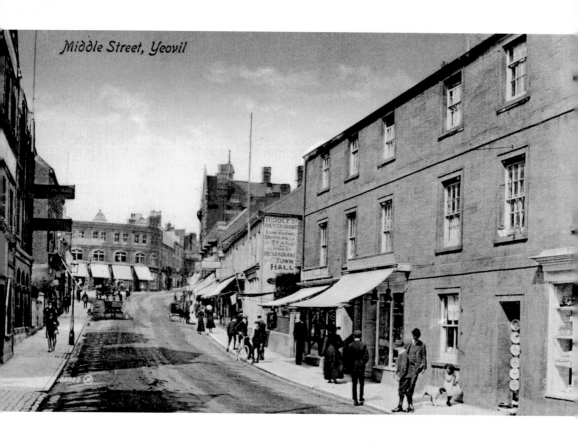

Middle Street, Yeovil

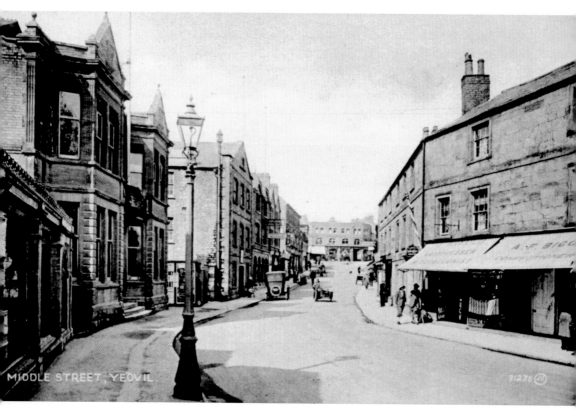

MIDDLE STREET, YEOVIL

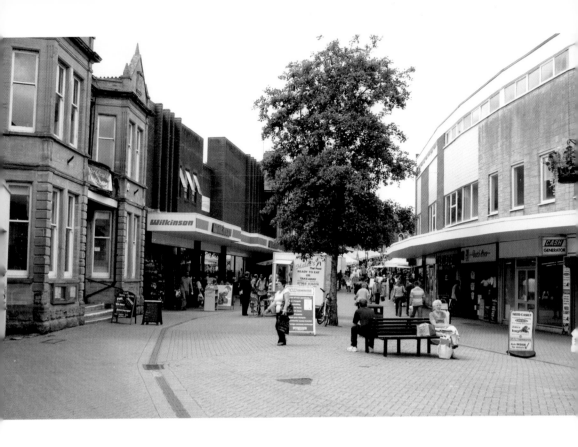

Lower Middle Street Looking West, *c.* 1912 and *c.* 1925

This part of Middle Street has changed completely since the two postcards on page 28 were published in 1912 and the mid-1920s. In the top view from 1912, the well-presented terrace of Hamstone properties on the right appear to have been turned into small shops on their ground floors, probably reflecting the growth of Middle Street eastwards during the second half of the nineteenth century. In the lower view, on the immediate left is a glimpse of Yeovil Gas Works' showrooms, followed by the Liberal Club (built in 1895) and the neighbouring substantial building housed the offices and printing works of the *Western Chronicle* weekly newspaper, published from 1886 to 1931. Today the pedestrian precinct in lower Middle Street attracts many shoppers and is the venue for the Tuesday and Friday markets, and also the occasional French market, shown in the modern photograph.

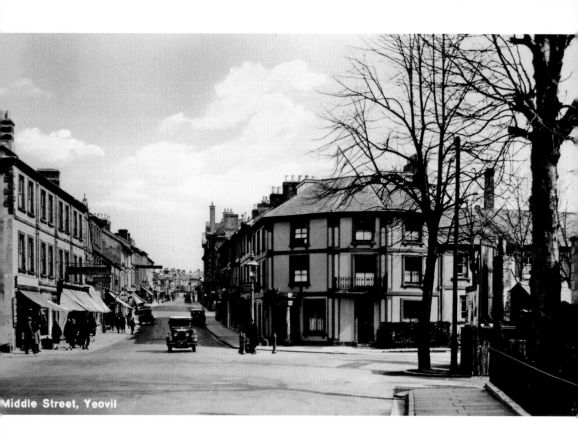

Middle Street, Yeovil

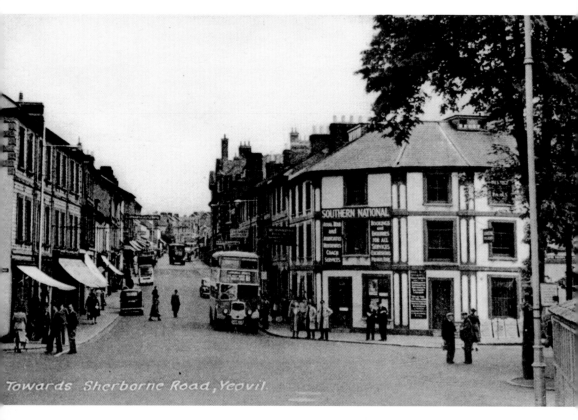

SOUTHERN NATIONAL

Towards Sherborne Road, Yeovil

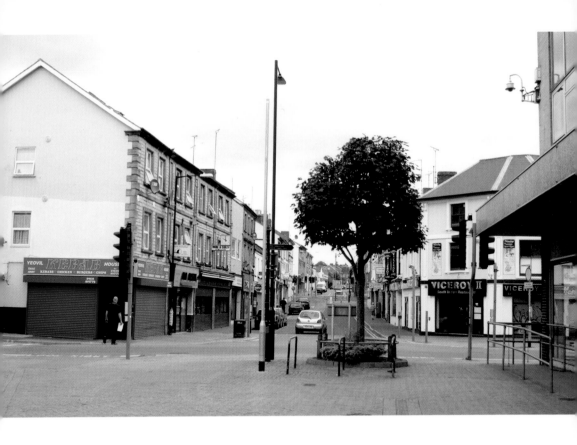

Lower Middle Street Looking Towards Sherborne Road, *c.* 1930 and *c.* 1955

Following the opening of the town station in 1861, there was rapid growth of commercial and residential development eastwards along London Road, and the road was renamed Middle Street up to the junction with Wyndham Street and Newton Road. The majority of the premises shown in the upper postcard from 1930 were built within a few years of 1861. The large building on the corner of Middle Street and Station Road was the Fernleigh Commercial Hotel, but in the lower postcard from the mid-1950s the offices of the Southern National Omnibus Company have become established in the premises. A closer look reveals that the double-decker bus is the number 1B serving the Larkhill Estate, and in the bottom right-hand corner there is a glimpse of a concrete bus shelter. Today, this part of lower Middle Street is a mixture of shops, restaurants and fast-food outlets.

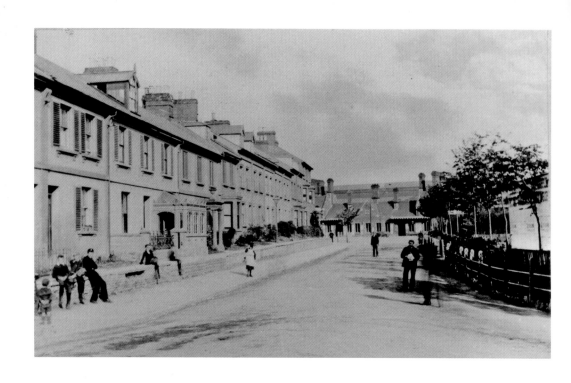

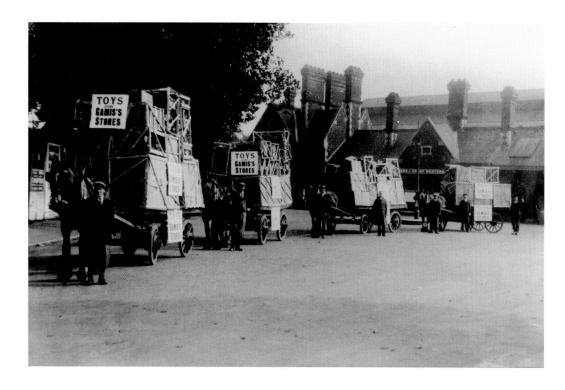

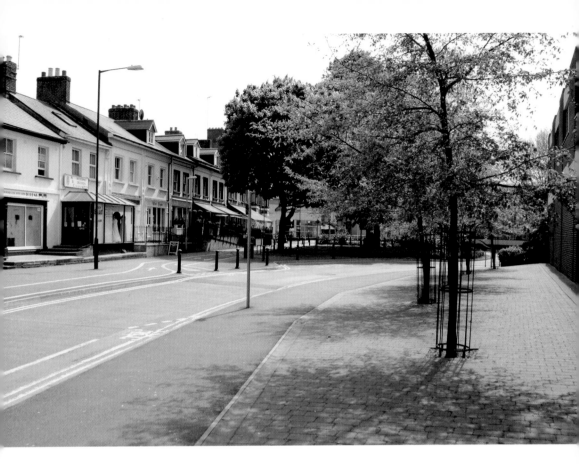

Station Road, *c.* 1896 and 1934

The upper photograph of Station Road on page 32 dates from about 1896, and the road leads past the rather fine buildings of South Western Terrace on the left down to the town station. However, the view from South Western Terrace was somewhat spoilt by the large coal yard on the opposite side of the road behind the small trees. In the lower photograph from 1934, four horse carts stand on the station forecourt about to transport toys to Gamis's Stores in High Street, having just collected the packing cases from the goods yard. The town station closed in 1967 and in 1971 was purchased by Yeovil Borough Council, which enabled the authority (and its successor, South Somerset District Council) to redevelop the area and construct Old Station Road (shown above).

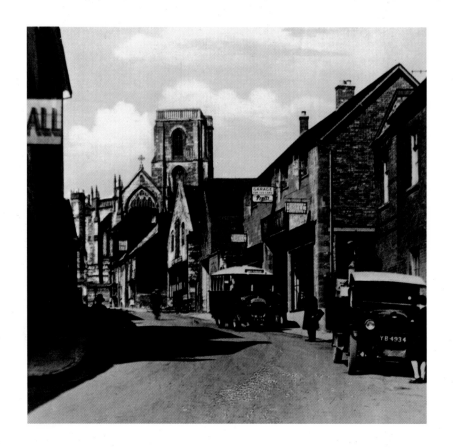

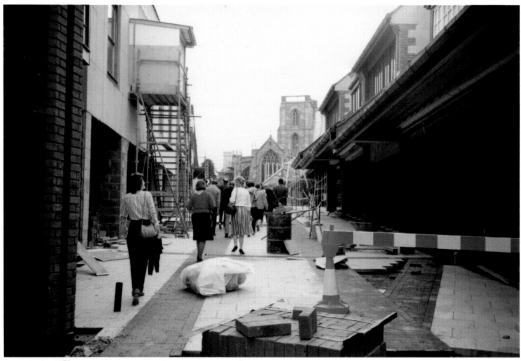

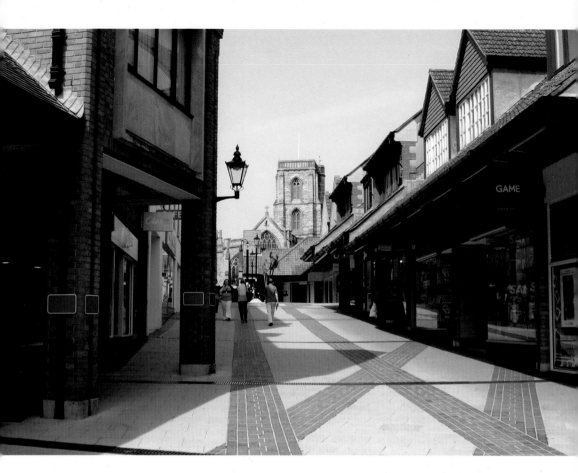

Vicarage Street/The Quedam, c. 1934 and 12 September 1984

The postcard at the top of page 34 was sent in November 1934 and shows St John's church looking down upon Vicarage Street, one of Yeovil's ancient thoroughfares and, apart from the motor vehicles, a scene probably little changed for a century. In April 1983, Vicarage Street was closed to traffic and work began on the Quedam Shopping Centre. Because of its extensive land holdings in the area, South Somerset District Council was a major partner in the scheme and the lower colour photograph, taken during the early evening of 12 September 1984, shows councillors and staff on a conducted tour of the development. Vicarage Walk, the pedestrian thoroughfare through the Quedam shown in the modern photograph, follows the line of the old Vicarage Street and its ancient predecessor, Quidam or Quidham — after which the shopping centre is named. In his book *Yeovil History in Street Names* (1988), a local historian, the late Leslie Brooke, suggests that the Latin word *quedam* meaning 'a property in a certain place' may have been the origin of the name.

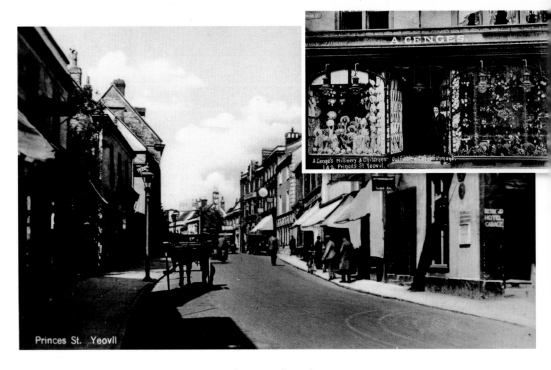

Princes Street Looking North, *c.* 1920 and *c.* 1910 (inset)

Princes Street has changed very little in the eighty or so years between these two views, and the shadow cast on the left of each picture is almost identical! The corner of Princes Street and Westminster Street was known for many years as 'Genge's Corner' after Alfred Genge, whose fancy draper's shop appears in the inset.

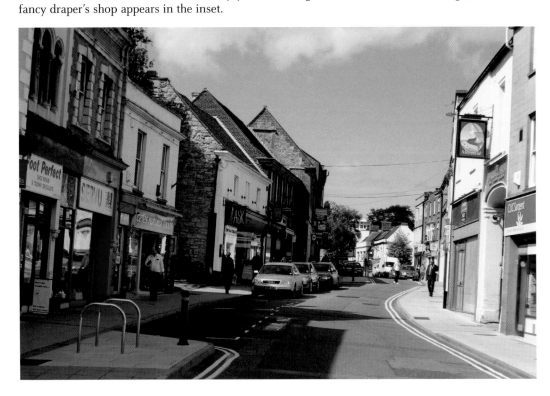

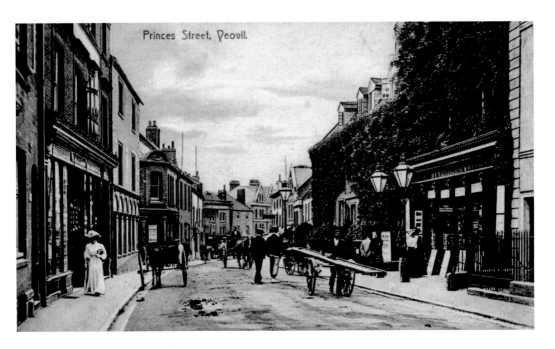

Princes Street Looking South, *c.* 1900

Once again these two views of Princes Street have changed little during the intervening century. On the left of the early postcard, the elegant lady dressed in white passes Handel House the premises of E. Price & Sons, retailers of pianos and organs. Note the organ pipes above the shop front, and, on the right with the two large gas lamps in the forecourt, is Albion House, Whitby's bookshop and stationers (established 1844).

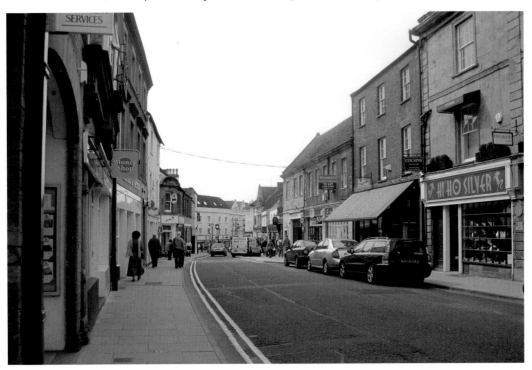

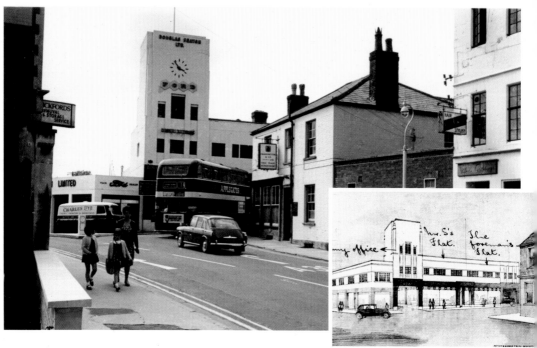

Westminster Street, *c.* 1965 and *c.* 1931 (inset)

In the earlier photograph, the tower of Douglas Seaton Ltd's motor showrooms and garage, built in 1931, dominates the junction of Westminster Street with Huish and Clarence Street. The publicity postcard sketch in the inset gives an idea of the building's original appearance. In 1990, the familiar landmark was demolished to make way for Tesco's store and large car park. Yeovil Town Football Club's Huish ground disappeared in the same retail development.

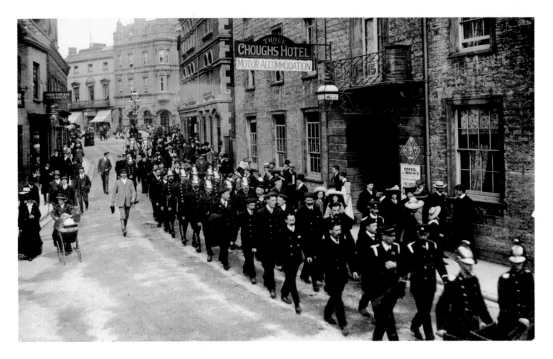

Hendford, The Three Choughs Hotel, 10 May 1906

Contingents of officers and firemen, representing nine fire brigades, attending the spring meeting of the Southern District of the National Fire Brigades' Union, march past the Three Choughs Hotel on their way to the brigades' competitions at West Hendford on 10 May 1906. The name of the early-eighteenth-century coaching inn is believed to have been derived from the three Cornish choughs represented in the attributed arms of Thomas Becket, Archbishop of Canterbury. The hotel, which was closed in 2004, has been converted to residential, professional and commercial use and renamed Becket House.

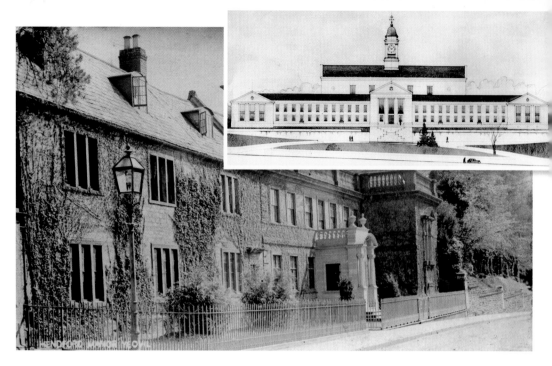

Hendford, Hendford Manor House, *c.* 1909 and *c.* 1938 (inset)

Hendford Manor House, shown in this postcard from a century ago, was built by James Hooper in 1750. Following the destruction of the town hall by fire, the Borough Council bought the house and grounds in 1936 for the site of a new town hall. Plans for the new building (shown in the inset) were approved but the outbreak of war in September 1939 stopped the project and it was never revived. Following the opening of the Johnson Hall/Octagon Theatre (1974), Hendford Manor House was sold for offices.

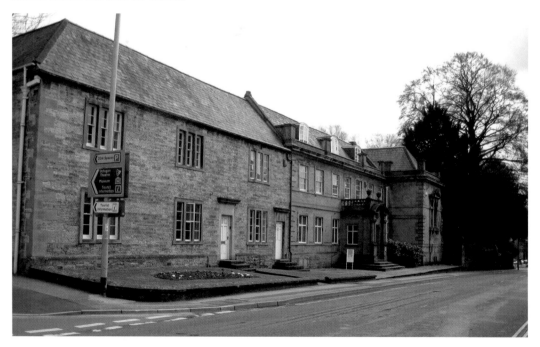

chapter 2

The Suburbs

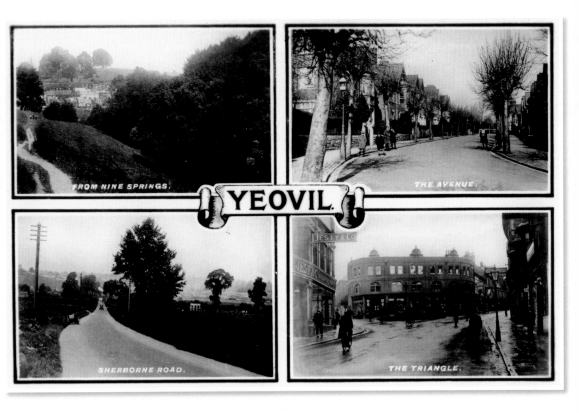

Yeovil multi-view postcard, *c.* 1920.

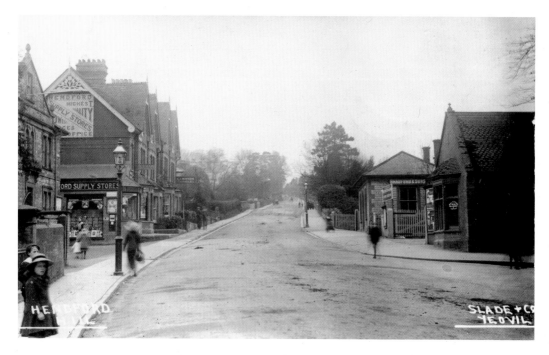

Hendford Hill Looking South, *c.* 1915

On 6 May 1915, Harry sent the postcard of Hendford Hill to Aunt F. in Johnstown, New York State, and today Harry could still recognise the hill. On the right, the two buildings flank the entrance to Hendford railway goods yard, Bradford and Sons' offices are clearly marked and the other building belongs to the Somerset Trading Company — both builders' and general merchants. The goods yard closed in the 1960s, and the two buildings were demolished for road widening. The large yellow sign advertises Bradfords, still trading as builders' merchants. Perhaps the greatest change is the traffic.

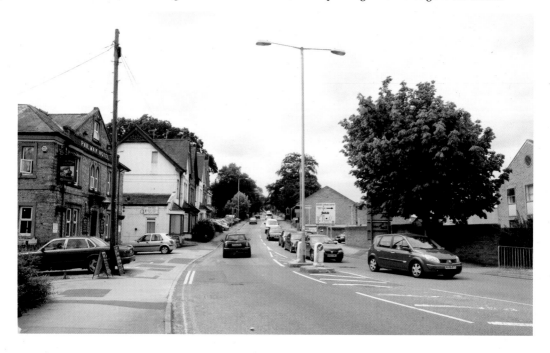

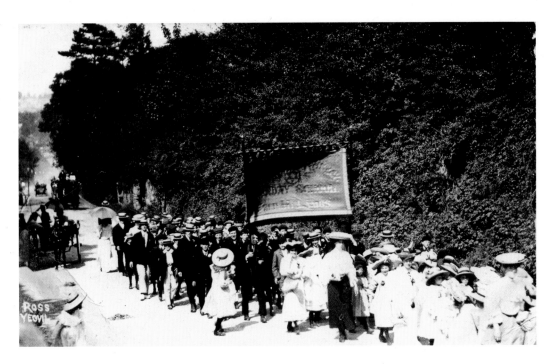

Hendford Hill Looking North, *c.* 1910

In the century-old postcard, the Wesleyan Sunday school scholars and their banner have almost reached the top of Hendford Hill and the field where they will have their summer picnic. Behind the column, a horse bus labours up the hill and, in the distance with a cloud of dust, is the future — a motor car. In the modern photograph, the service bus and cars make easy work of Hendford Hill and without the dust!

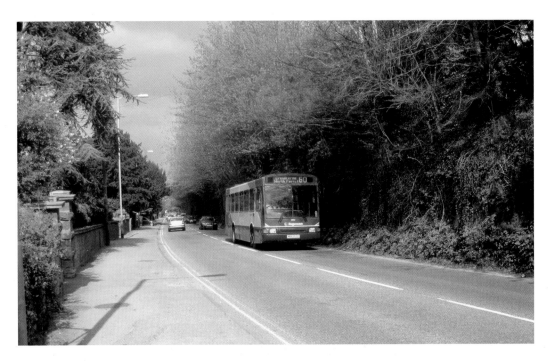

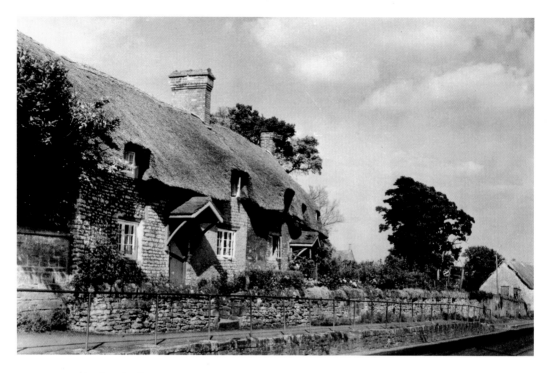

Preston Road, Thatched Cottages, August 1947

The parish of Preston Plucknett was absorbed into the Borough of Yeovil in 1929, but managed to retain much of its village character until the 1970s when large-scale residential, business and retail development spread into the area. Until some forty years ago thatched cottages stood near St James' church, but a number were demolished for road widening and the old photograph from August 1947 shows a pair of them. In the modern photograph, the site of these cottages was behind the hedge above the long wall.

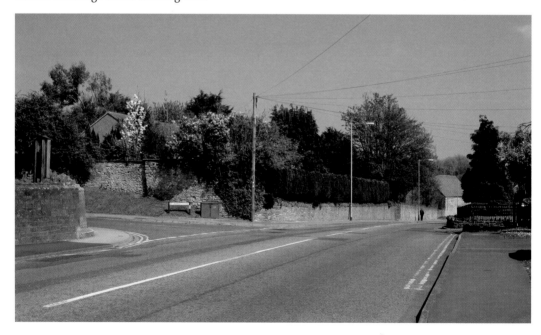

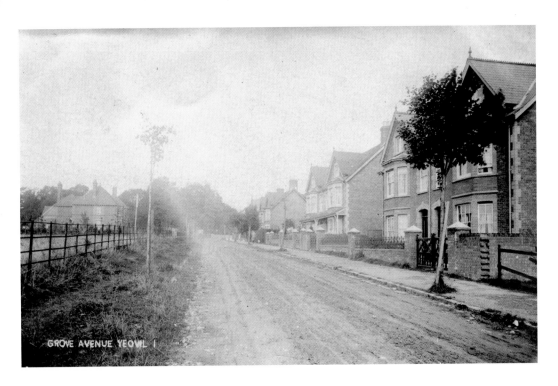

Grove Avenue, c. 1905

This rather hazy postcard of Grove Avenue was sent on 7 January 1905 by Mr L. Wheeler, of 'Keswick', Grove Avenue to Miss A. Cook of Southsea, asking if she could find 'Keswick' in the picture. The houses shown in the postcard are on the east side of Grove Avenue and development has yet to start on the west. However, young trees have been planted and can be seen on both sides of the road. In the modern photograph, the trees and the houses have matured but Grove Avenue is easily recognisable even with the cars.

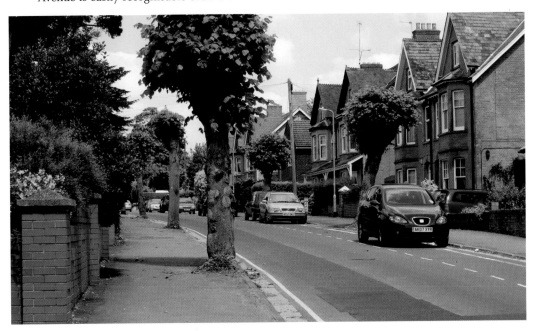

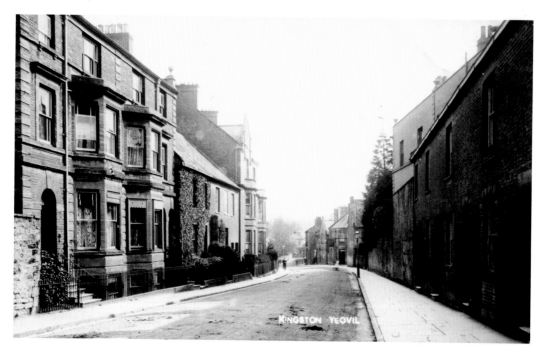

Kingston, *c.* 1900

How Kingston has changed since the early postcard was published a century ago! Although the terrace of houses on the right and the large house beyond can be seen in both old and new pictures, all the houses on the left were demolished some forty years ago for the construction of the Kingston dual carriageway and the new Yeovil District Hospital which opened in October 1973. The new photograph shows part of the hospital and, refreshingly, just for a moment a dual carriageway empty of motor vehicles!

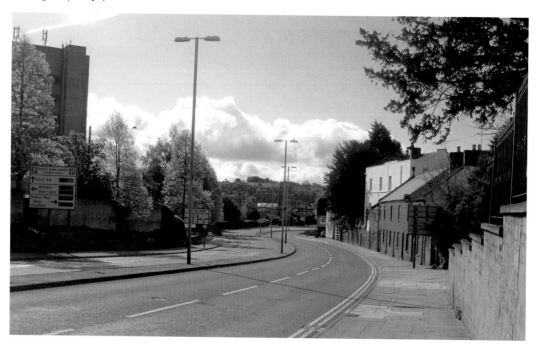

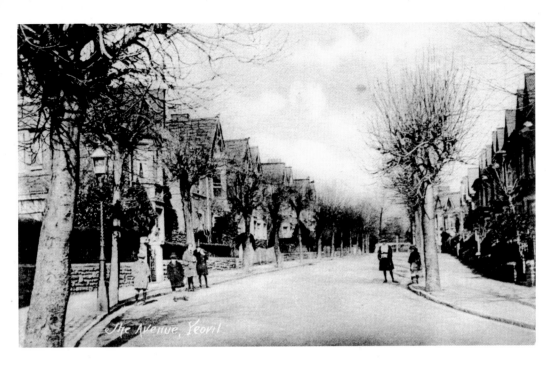

The Avenue, c. 1920

Plans for the new street, to be named The Avenue, were passed in May 1895, and within five months the first seven houses were occupied. Some thirty years later, looking north up The Avenue on a winter's day, six children pose for the camera in a scene which, apart from the trees being in full leaf and parked cars, remains almost unchanged in the modern photograph.

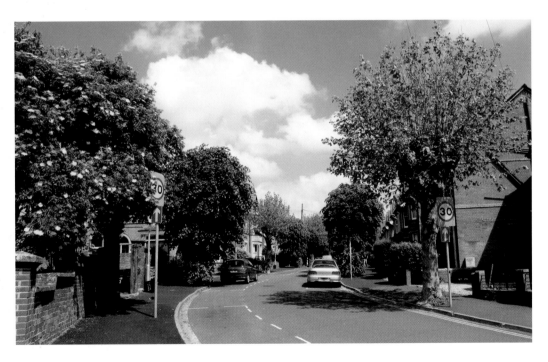

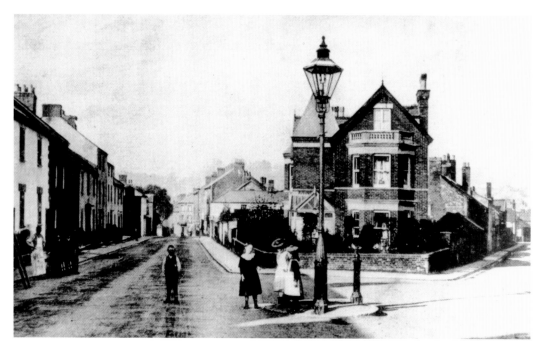

Sherborne Road/Reckleford Junction, *c.* 1898
There is not a vehicle in sight in the old photograph, taken around 1898 at the junction of
Sherborne Road and Reckleford, and it is in complete contrast with the modern photograph. The
triangle formed by Sherborne Road, Wyndham Street and Reckleford, of which this is the eastern
apex, has been dubbed Yeovil's 'Bermuda Triangle' on account of the traffic congestion. At the
time of writing, work is underway on a major highway improvement scheme which aims to rid
the town of one of its worst traffic bottlenecks.

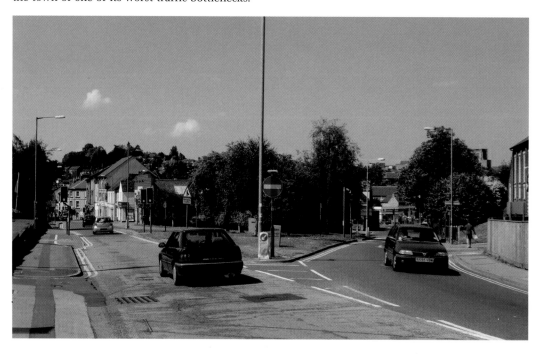

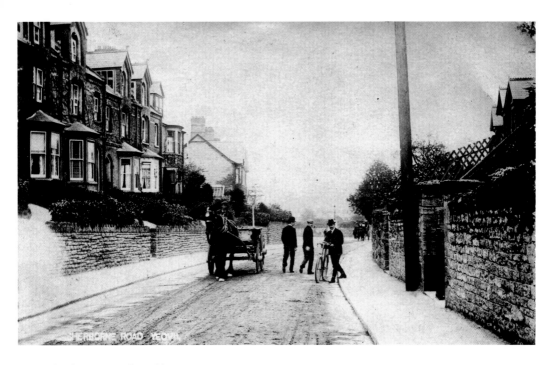

Sherborne Road Looking East, *c.* 1904

It is surprising how little some street scenes change in a century. All the houses and walls in the postcard of Sherborne Road from 1904 are still recognisable and only the cars, the traffic sign and the double-yellow lines are noticeably different in the modern photograph. Just beyond the figures in the 1904 picture, the road branches right for Sherborne and left for Lyde Lane at the end of which was the dreaded fever isolation hospital.

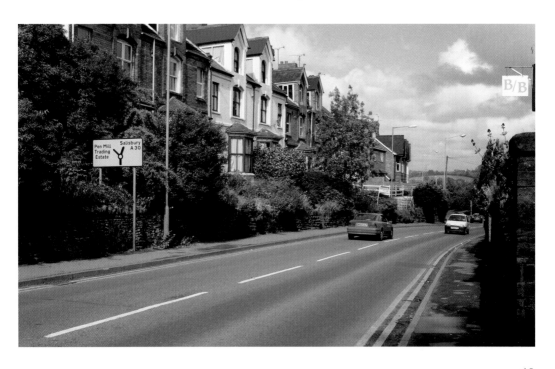

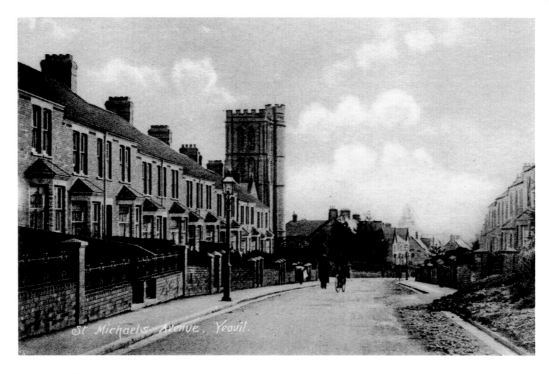

St Michael's Avenue, c. 1920

In this 1920s postcard of St Michael's Avenue looking south, the entrance to Grass Royal has not been fully opened as shown on the right of the modern photograph. By the time the postcard was published, this part of Yeovil had expanded rapidly, and the country lane known as Brickyard Lane had been made into a substantial residential road and renamed St Michael's Avenue.

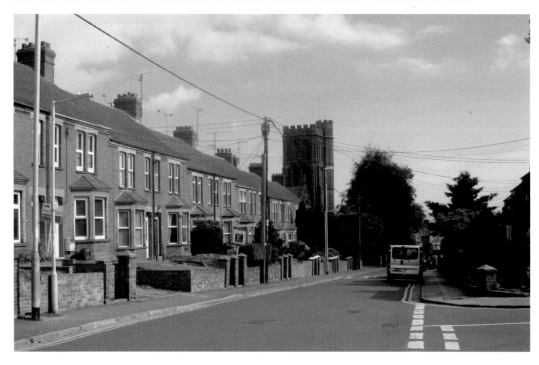

chapter 3

Transport

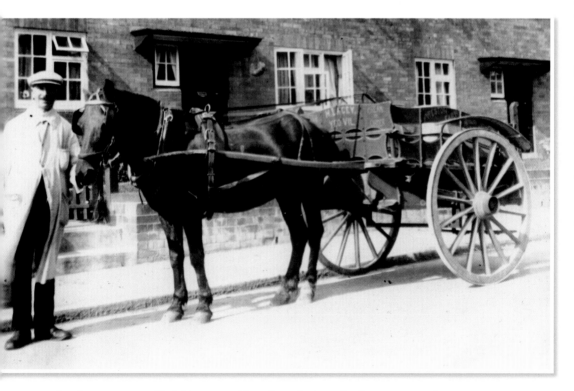

One-horse power milk delivery cart (thought to be Lacey's of Preston Farm) *c.* 1920.

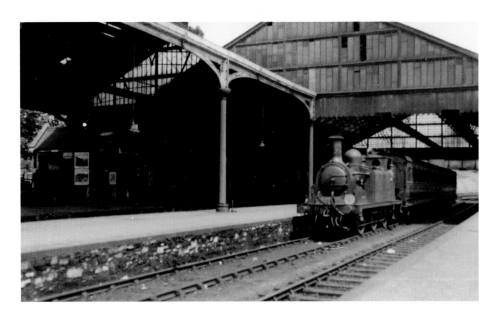

Yeovil Town Station, *c.* 1930
Waiting at Platform 2 is an ex-London, Brighton & South Coast Railway, D1 class (0-4-2) tank locomotive, which provided the 'push-pull' shuttle service to Yeovil Junction Station. The two overall glass roofs, dating from the opening of the station (1 June 1861), were removed in 1934. Following the infamous Beeching 'axe' the station closed in 1967. In the colour image of Yeo Leisure Park, the loco would have stood slightly to the right of the ubiquitous white van. The inset shows the original station date-stone (rather premature for the actual opening!) that now adorns an adjacent flowerbed.

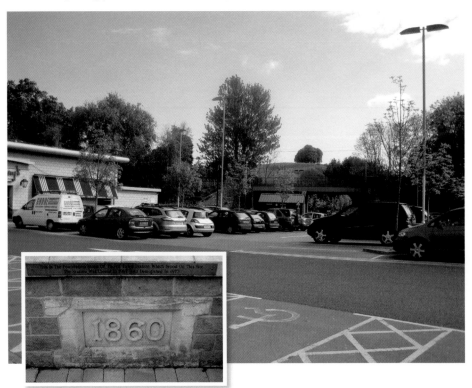

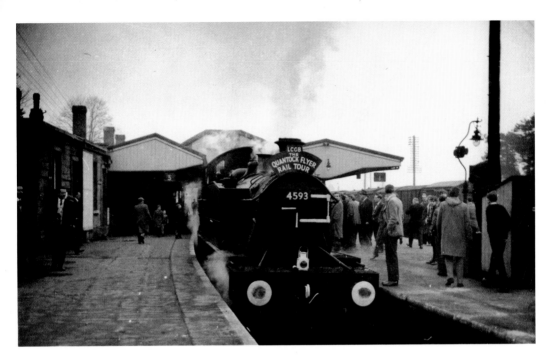

Yeovil Pen Mill Station, 16 February 1964

The 'Quantock Flyer' rail tour, organised by the Locomotive Club of Great Britain, was double-headed by locomotives no. 4593 (2-6-2) prairie tank and no. 9663 (0-6-0) pannier tank. It is seen here about to depart for Taunton, via Yeovil Town and Durston. Yeovil Pen Mill Station was opened by the Wilts, Somerset & Weymouth Railway (GWR) on 1 September 1856 and retains many of its original features. Today it is a passing loop on the single-line section between Castle Cary and Maiden Newton. The lower image shows a First Great Western class 158 'Express Sprinter' DMU awaiting departure for Weymouth.

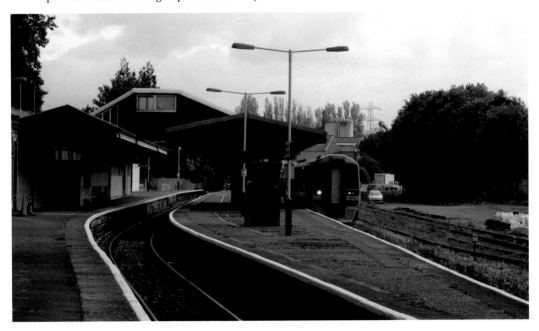

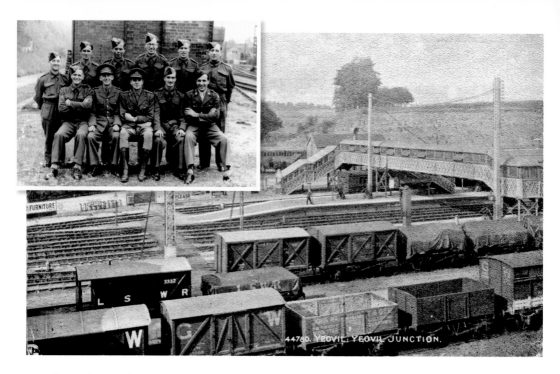

Yeovil Junction Station, *c*. 1910 and 12 July 1943 (inset)

Yeovil Junction Station, constructed by the Yeovil & Exeter Railway (LSWR), opened on 19 July 1860. Over time its covered footbridge has been sadly reduced to an ungainly shadow of its former self! However, a rare survival is the station's 1945 turntable, regularly used by visiting 'steam specials' at the adjacent Yeovil Railway Centre. In the modern photograph, is an Exeter-bound, South West Trains class 159 'South Western Turbo' DMU. Inset is a wartime image of the Rail Transport Officer's staff on the goods platform, including Sergeants N. B. Johnson (British Army) and 'Marco' (United States Army) — no other identities are known.

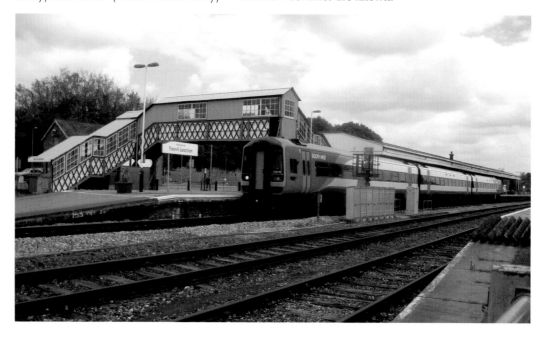

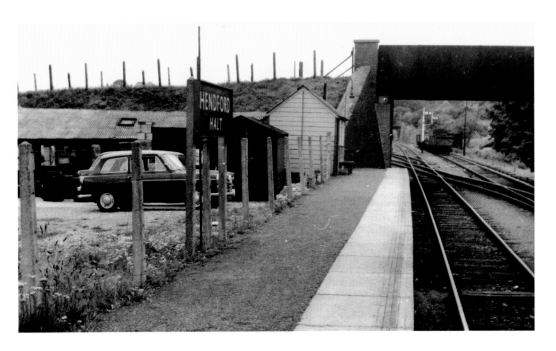

Hendford Halt, *c.* 1963

Hendford Halt is often confused with Hendford Station. The latter was Yeovil's first railway station, connecting the town with Taunton — opened on 1 October 1853. Built by the Bristol & Exeter Railway, it was situated just beyond the Yew Tree Lane over-bridge. However, its life as a passenger station was short-lived, being superseded by the more centrally located Yeovil Town Station (1861). The Halt itself, opened on 2 May 1932, was built largely for the convenience of the nearby Westland Aircraft factory (established 1915). Closing in 1964, the trackbed (truncated in the lower image by Lysander Road) has become a pleasant foot- and cycle-path, through Yeovil Country Park to Yeovil Pen Mill Station.

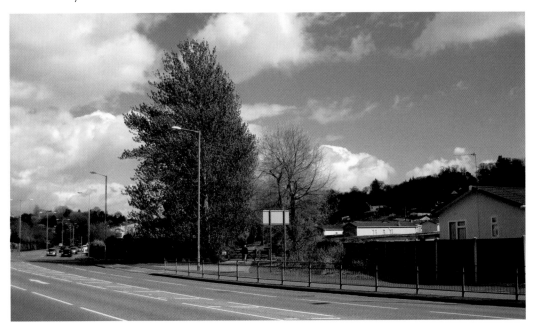

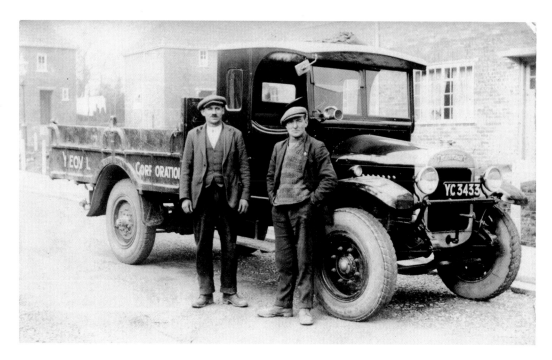

Thornycroft Long-bodied two-ton Lorry (A2/FB4 /YC 3433), Hillcrest Road, *c.* 1930
This lorry was powered by a four-cylinder 3620cc petrol engine. Fitted with pneumatic tyres and electric lights as standard, it was quite a revolutionary design at the time. Yeovil Borough Council purchased this vehicle in 1928 and used it until 1948! Such longevity is unlikely to be equalled by the Iveco 'Daily' truck (WA57 BTF), in the colour photograph. The identities of the 'Andy Caps' are unknown, but those of the South Somerset District Council grounds staff are: (left to right) Tom Lake, Rodney Pippard and Paul Harding, 'on location' at Yeovil Recreation Centre.

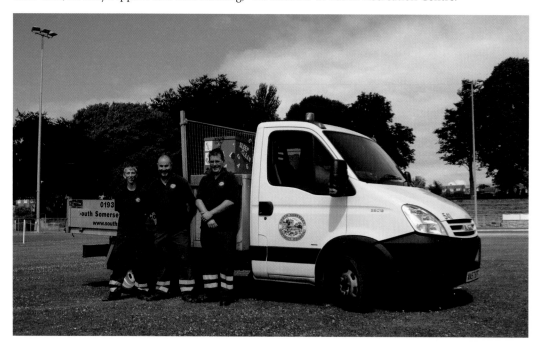

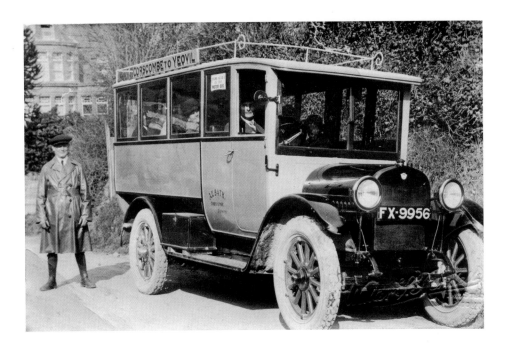

REO Fourteen-seater Motor Bus (FX 9956), Dorchester Road, 1923

Albert Edward Bath owned and operated this motor bus, 1922-1935 — until bought out by the Southern National Omnibus Co. On the side window, a notice reads: 'Corscombe — Halstock — East Coker motor bus' — though it did end up in Yeovil (as the rooftop destination board indicates). The single fare for the whole journey was a princely one shilling and threepence (now 6p!). Fuel consumption was fifteen miles to the gallon, over an arduous route that included one-in-eight hills and loose road surfaces (notice the muddy tyres). The Mercedes bus (N457 VOD), photographed in the Borough, provides a similar service today — though encountering slightly less difficulties!

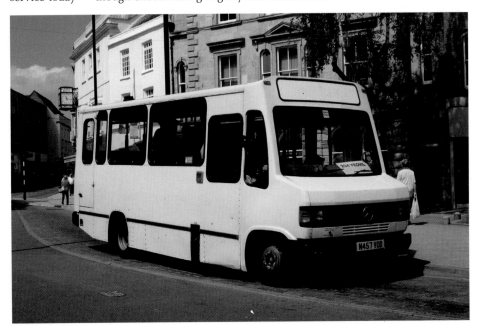

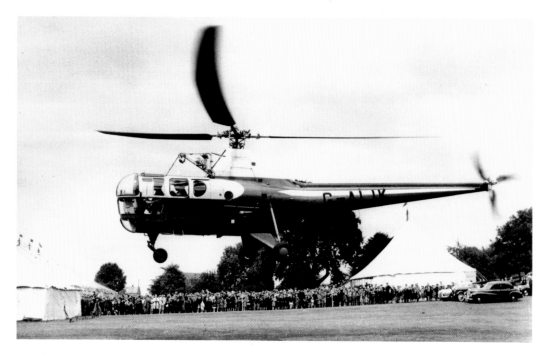

Westland Dragonfly Helicopter, Hendford Manor House, 3 July 1954
This Westland Dragonfly had a distinguished passenger on board when it touched down at the opening of the 1954 Yeovil Trades Fair — Marshal of the Royal Air Force Sir John Cotesworth Slessor. The fair was held in the grounds of Hendford Manor House and was judged a great success. This helicopter was a four-seat general purpose model, powered by a 520hp Alvis Leonides radial piston engine. Its maiden flight took place in 1948 — marking Westland's entry into the rotary-winged field. The modern image is of an AgustaWestland AW109E Power (G-UKAW), hovering over Westland airfield.

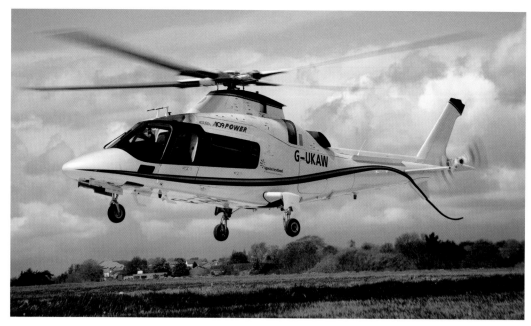

chapter 4

Entertainment

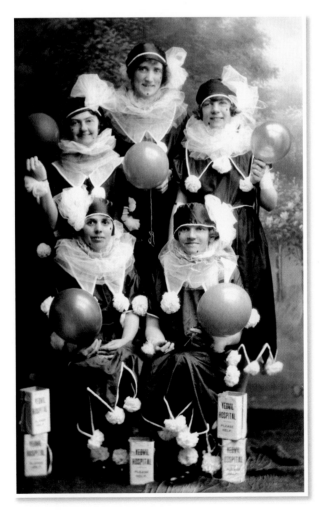

Yeovil Hospital Carnival, *c.* 1923.

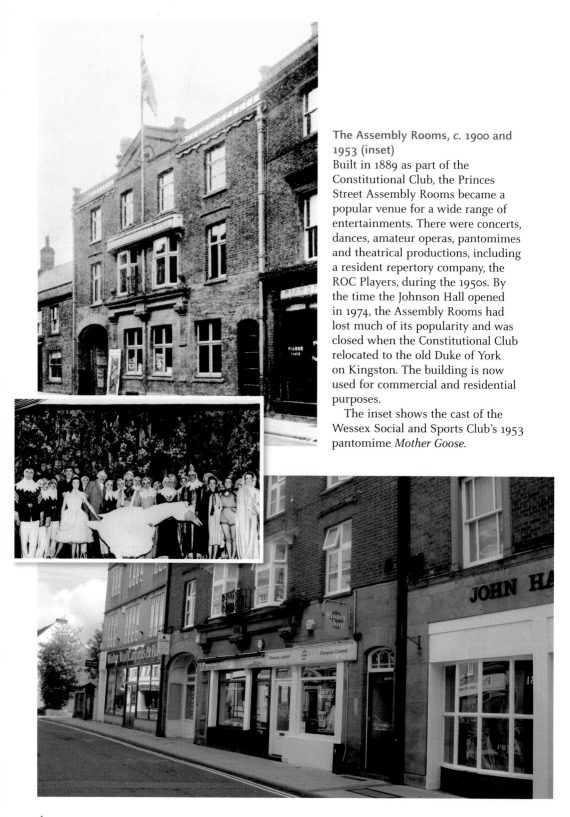

The Assembly Rooms, *c.* 1900 and 1953 (inset)

Built in 1889 as part of the Constitutional Club, the Princes Street Assembly Rooms became a popular venue for a wide range of entertainments. There were concerts, dances, amateur operas, pantomimes and theatrical productions, including a resident repertory company, the ROC Players, during the 1950s. By the time the Johnson Hall opened in 1974, the Assembly Rooms had lost much of its popularity and was closed when the Constitutional Club relocated to the old Duke of York on Kingston. The building is now used for commercial and residential purposes.

The inset shows the cast of the Wessex Social and Sports Club's 1953 pantomime *Mother Goose*.

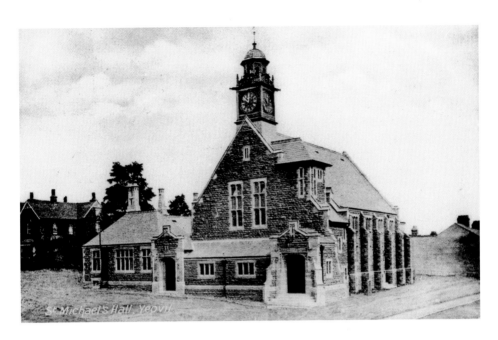

St Michael's Hall, *c.* 1908

St Michael's Hall was opened in 1908 to serve the residents of the rapidly expanding parish of St Michael and All Angels. It became the venue for a wide variety of entertainments, from socials to film shows and indoor sports and games. During the Second World War (1939-1945) barrage balloons were repaired in the hall, as it was the only building in Yeovil with sufficient indoor height to enable the balloon to be inflated and the repair checked. Today the hall is managed by the South Somerset District Council for a variety of community leisure activities.

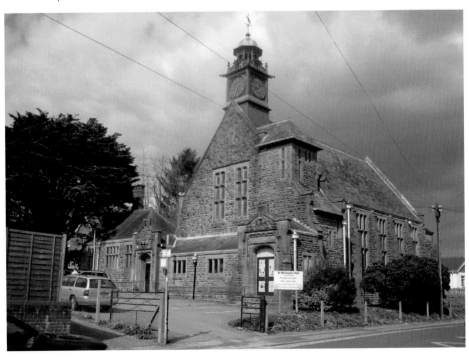

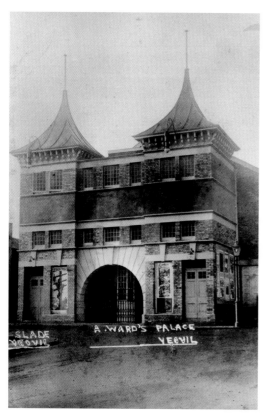

The Palace Cinema, *c.* 1913

'A WARD'S PALACE', shown in the old photograph, opened for film shows and stage performances at the Triangle on 10 February 1913. Following its sale in 1929 to the Gaumont-British Picture Corporation, the Palace was demolished and a new Gaumont cinema, declared 'A Triumph of Modern Art', opened on 15 December 1934. The modern photograph shows the building virtually unchanged during the past seventy-five years, and although the Gaumont closed for films in 1972, and more recently for Bingo, the old cinema remains a well-known Yeovil landmark.

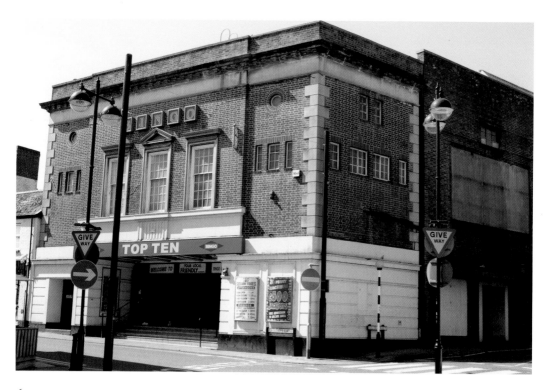

The Central Cinema, c. 1960
The Persian-style Central Cinema, shown
in the earlier photograph, was opened
on Church Street in January 1932 and
replaced the original Central Hall Picture
Palace which had burnt down on 24 May
1930. Although the Central operated as an
independent cinema and often showed
films the major cinema chains did not the
decline in audiences during the 1960s forced
its closure in May 1964. Following some
years as a Bingo and Social Club, the Central
finally closed in 1979 and was demolished
nine years later, and the new building on
the site is occupied by a firm of solicitors.

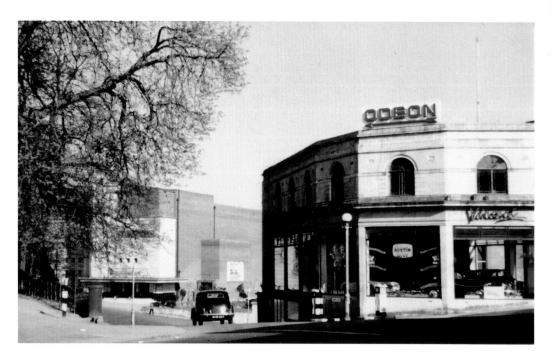

The Odeon, *c.* 1950

Described as a 'Beautiful Shirley Temple among cinemas', the Odeon on Court Ash was opened on 8 May 1937 and was one of over 250 Art Deco-style super-cinemas built by the Oscar Deutsch cinema chain. The brand name Odeon was coined from 'Oscar Deutsch Entertains Our Nation', and the cinema bore the name until 1971 when it became a Classic. In 1984, Cannon took over, followed by MGM in 1992 and finally ABC in 1996. The ABC cinema closed on 31 March 2002, and on 3 January 2004 the Old Cinema Bed Centre opened in the Art-Deco building.

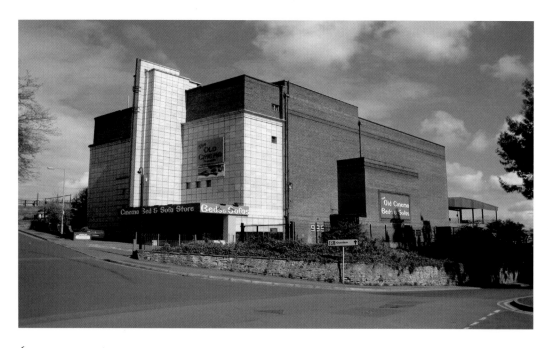

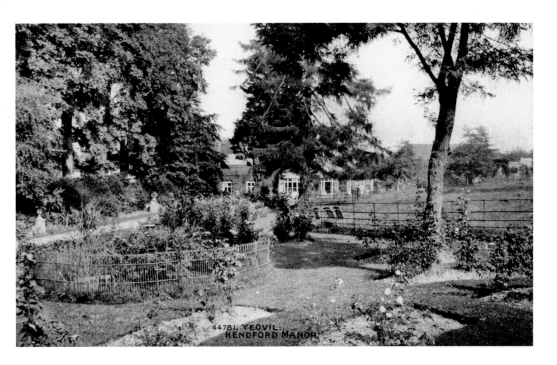

The Octagon Theatre/Johnson Hall, *c.* 1900

The garden of Hendford Manor House, shown in the earlier photograph, is now occupied by the Octagon Theatre, Yeovil's premier venue for live concerts and theatre. Opened in 1974 by the Yeovil (now renamed South Somerset) District Council as the multi-purpose Johnson Hall, it became apparent within a decade that the building was more suitable for theatre, and from a local press competition the name 'Octagon' was chosen in 1984. From successive improvements during the past twenty-five years, the Octagon has emerged as a major regional theatre.

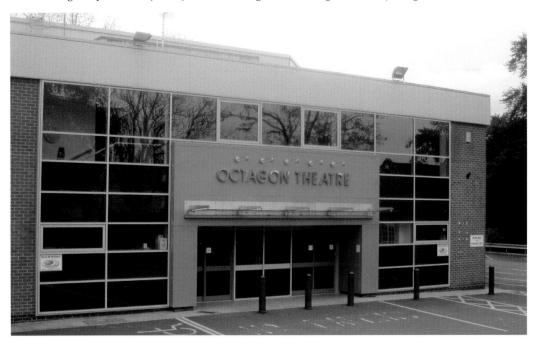

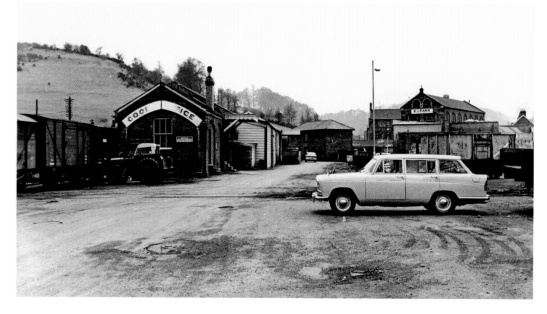

Yeo Leisure Park, *c.* 1965

The estate car shown prominently in this photograph, taken about forty years ago, stands at the entrance to the Yeovil Town Station goods yard. On the right can be seen the premises of E. J. Farr's scrap metal business, and just behind there is a brief glimpse of Pulman's glove factory, now known as Foundry House. Following the closure of the town station, the goods yard formed part of a public car park and, in 2002, Yeo Leisure Park, shown in the new photograph taken from the Newton Road bridge, opened on the site providing a range of entertainments and restaurants.

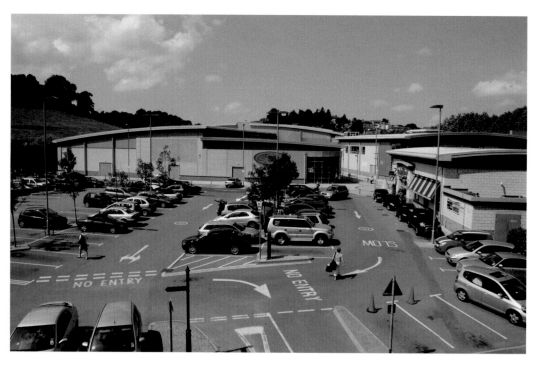

chapter 5

Parks & Gardens

Yeovil multi-view postcard, *c.* 1925.

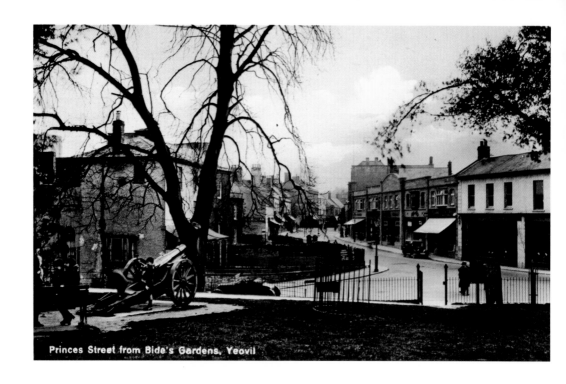

Princes Street from Bide's Gardens, Yeovil

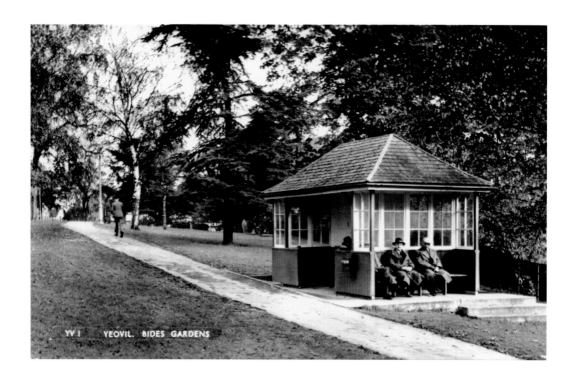

YV 1 YEOVIL, BIDES GARDENS

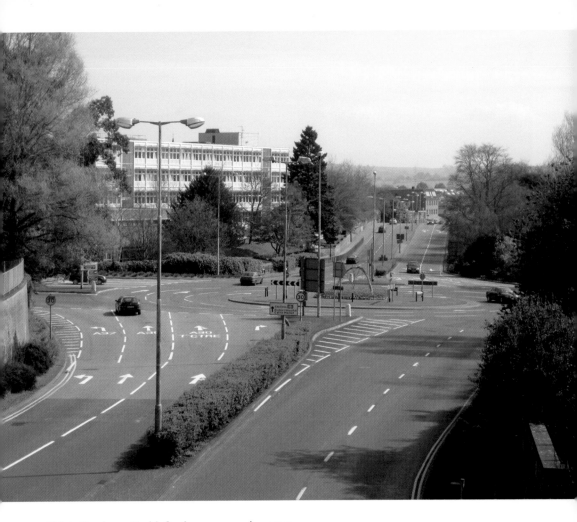

Bide's Gardens, Reckleford, c. 1930 and c. 1950

The two older postcards show the sylvan tranquillity that used to exist remarkably close to the town centre, prior to the construction of the Reckleford dual carriageway in 1966. Bide's Gardens had been created by the Yeovil Borough Council in 1921, as a direct result of widening of Court Ash between Higher Kingston and Kingston. The cost of the widening scheme was partly financed by central government to relieve local unemployment. The name 'Bide's Gardens' honours the original donor of the land — the Dampier-Bide family of Kingston Manor House. The field gun 'gate-guardian' was a relic from the First World War (1914-1918) and was no doubt used as 'salvage' to aid the war effort in the Second World War (1939-1945)! Remnants of Bide's Gardens can still be traced today, in the grass verge and trees between between Court Ash and Reckleford, and in the greensward outside Yeovil District Hospital.

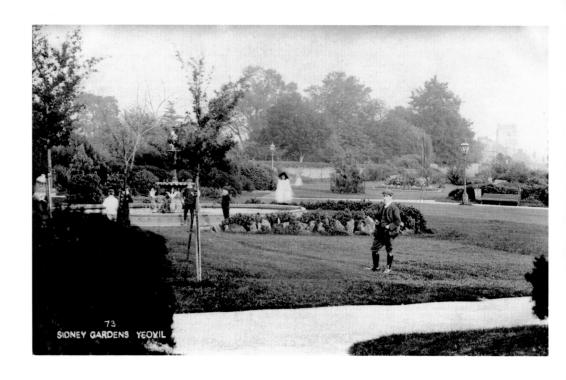

73
SIDNEY GARDENS YEOVIL

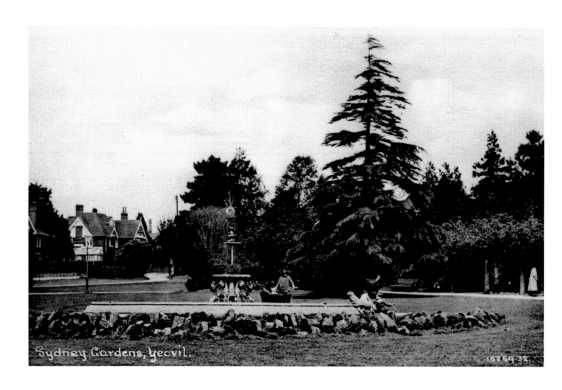

Sydney Gardens, Yeovil.

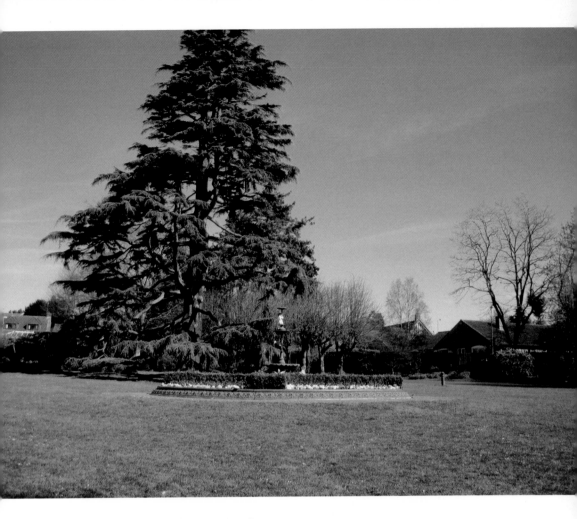

Sidney Gardens, The Park, *c.* **1906 and** *c.* **1920**
At a special meeting of the Yeovil Borough Council in June 1897, it was resolved to accept the generous offer of the mayor, Sidney Watts, to donate land at Ram Park (now The Park) as a pleasure garden. Though named Sidney Gardens (and not 'Sydney Gardens' as in the lower postcard!), it was created to commemorate Queen Victoria's diamond jubilee. Laid out in the style of a London park, complete with a rustic bandstand, it was formally opened on 23 June 1898. The following year an ornamental fountain was unveiled to celebrate the Queen's eightieth birthday. Though the bandstand has long gone, the fountain remains amidst the still-lush sylvan setting.

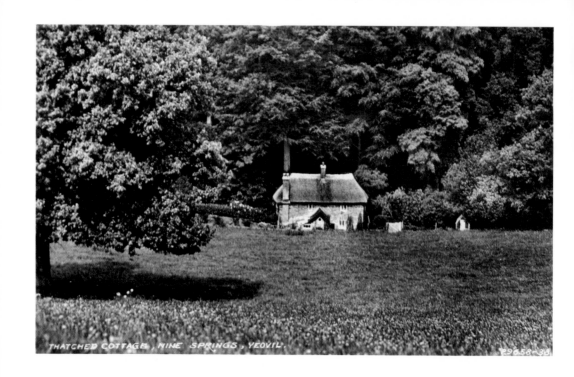

THATCHED COTTAGE, NINE SPRINGS, YEOVIL

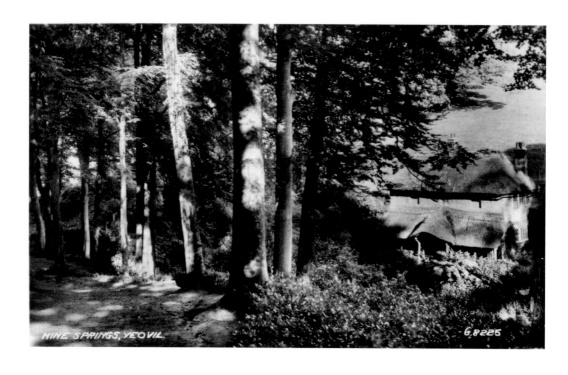

NINE SPRINGS, YEOVIL.

72

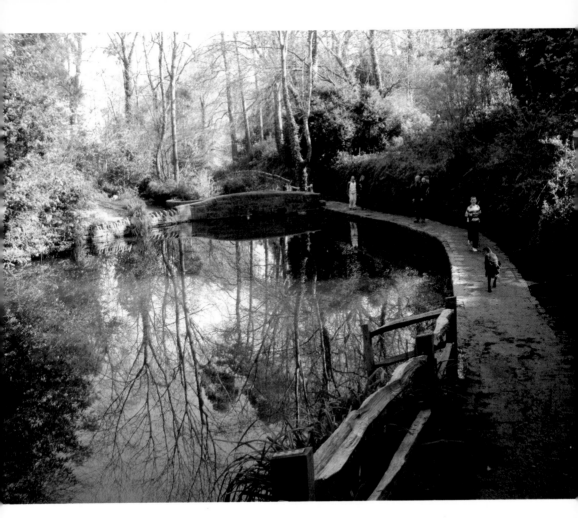

Nine Springs, c. 1938 and c. 1939

Nine Springs originated in the 1830s as the private pleasure grounds of the Batten family of Aldon House. It was designed using natural springs and features to provide ponds, waterfalls and paths in a woodland landscape of specimen trees. The Yeovil Borough Council leased the land for public access in 1932, and admission was by ticket only, obtainable from the Town Clerk — who just happened to be Colonel Henry Copeland Cary Batten of Aldon! By the mid-1960s the condition of Nine Springs had deteriorated to such an extent that clear felling and replanting of the slopes was necessary. In 1979 Yeovil (now South Somerset) District Council bought the site and further extensive restoration and improvements have been carried out since — it now forming part of Yeovil Country Park. The much-photographed thatched cottage (viewed from the rear in the upper postcard and front in the lower) used to serve light refreshments. Sadly, it was neglected, fell into disrepair and was eventually demolished many years ago.

Yeovil Cemetery, Preston Road, *c.* 1900

Though not a conventional park or garden, Yeovil Cemetery could be considered a garden of remembrance in a parkland setting. It was created in 1860 following a damning report into the condition of the town's public health. The Rammell Report (1852), commissioned by the General Board of Health, had stated that 'the malignant fever which broke out... might have originated from the noxious effluvia emanating from the churchyard'. Indeed, numerous witnesses pointed their finger at the overcrowded nature of St John's churchyard. Subsequently, it was closed for further burials and almost all the monuments were removed. The cemetery's two Romanesque mortuary chapels were reserved for Church of England (on the right) and Nonconformist burials.

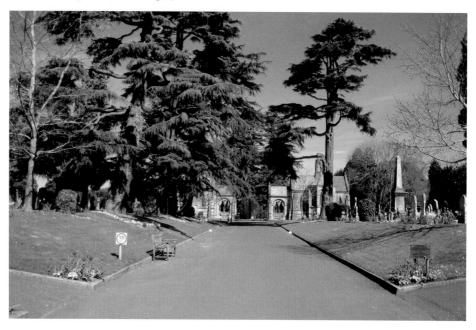

chapter 6

Events

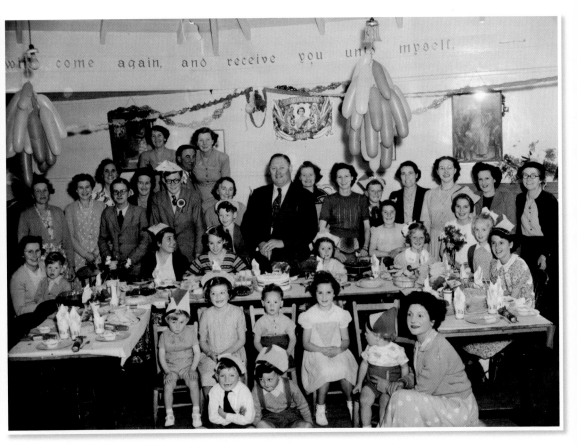

Orchard Street children's tea party, Huish Baptist Sunday Schoolroom, Coronation Day,
2 June 1953.

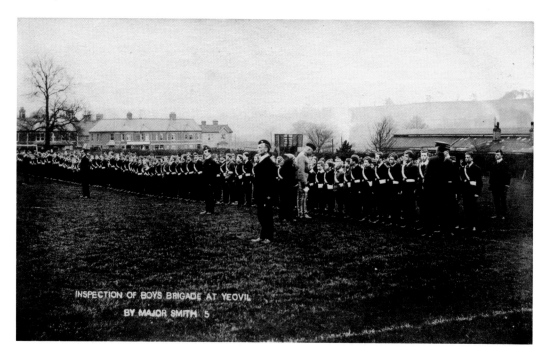

INSPECTION OF BOYS BRIGADE AT YEOVIL
BY MAJOR SMITH 5

Yeovil Boys' Brigade Inspection at Pen Mill, 1905
In this 1905 photograph, Major W. A. Smith, the founder of the Boys' Brigade, inspects the Yeovil Battalion on the Pen Mill Athletic Ground, the home of the Yeovil Casuals Football Club, and next to the Pen Mill Hotel. The roof of Yeovil Pen Mill Station can be seen at the right of the photograph, and a glimpse of goal posts on the left. The use of the ground ceased in the 1920s when football transferred to Huish, and it has remained open land ever since.

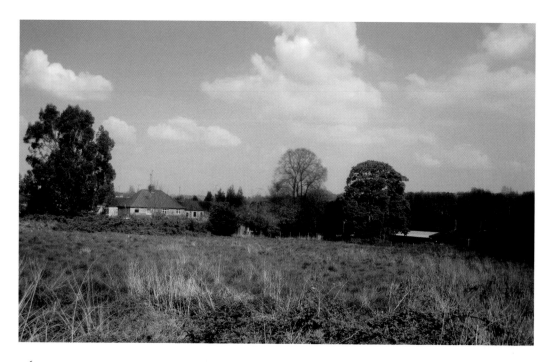

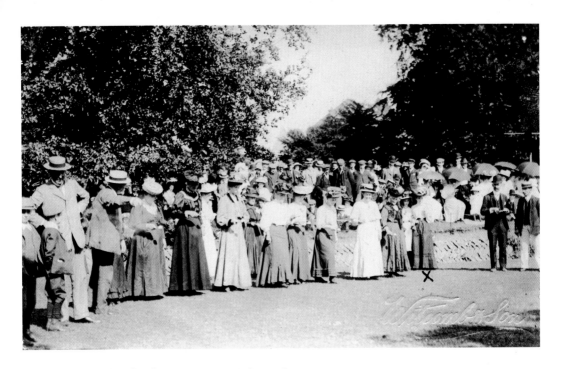

Yeovil Adult School Sports Day, 25 July 1908

In the older photograph, taken on the fine Saturday afternoon of 25 July 1908, ladies line up for the egg and spoon race at the Yeovil Adult School Sports Day, held in the grounds of Hendford House by kind permission of Miss Hinuber. The Yeovil Adult School was part of a national organisation established to provide educational opportunities for working people. Hendford House was built in 1776 by John Daniell, but in 1927 it ceased to be a private residence and became the Manor Hotel.

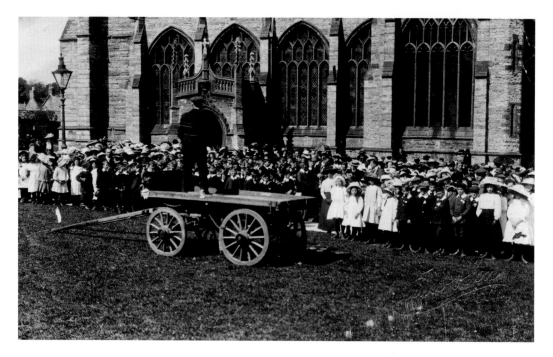

South Somerset Music Competition, April 1912

This postcard was sent in May 1912 and shows some of the young people participating in the South Somerset Music Competition in St John's churchyard on 23 to 25 April 1912. The 1912 competition of vocal and orchestral music was just one of the many and varied events held over the years in the churchyard, which is now delightfully planted with flowers by South Somerset District Council. In May 2009, when the spring bedding plants were removed they were given away to members of the public, as shown in the new photograph.

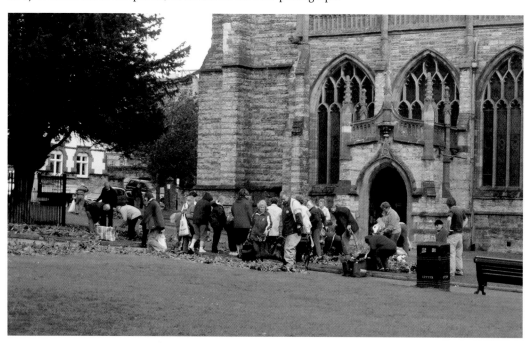

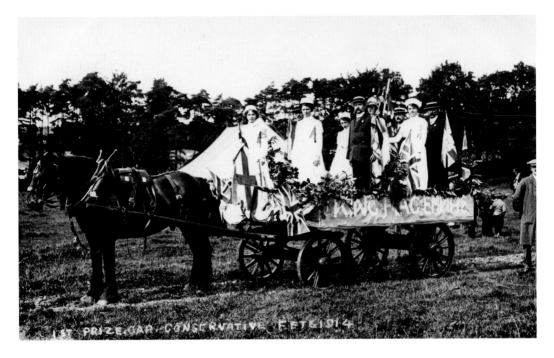

Conservative and Unionist Association Fête, 4 August 1914
The patriotic slogan 'KING FLAG EMPIRE' may have influenced the judges to award first prize to the competitors shown in this postcard, at the Conservative and Unionist Fête held in Yew Tree Close Park on Tuesday 4 August 1914. Only the day before, Germany had declared war on France, and at 11 p.m. on that Tuesday evening Great Britain and the Empire declared war on Germany. Lysander Road, shown in the modern picture, now crosses Yew Tree Close Park.

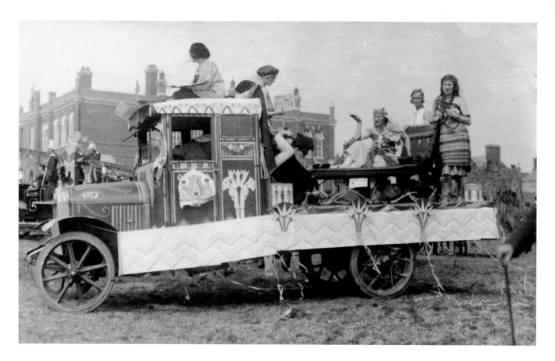

Yeovil Hospital Carnival, 7 July 1923

Students of the Yeovil School of Art won third prize for their tableau 'Art Students throughout the Ages' and are shown lined up for judging on the Fairfield at the Yeovil Hospital Carnival on Saturday 7 July 1923. In the background is Huish Junior School. One part of the Fairfield now forms part of the Queensway dual carriageway, opened in 1977, and the public car park shown in the modern photograph covers the place where the students parked their tableau. Huish Junior School was demolished in 1991 and replaced by Tesco's petrol filling station. In 1990, the school was relocated on the opposite side of Queensway.

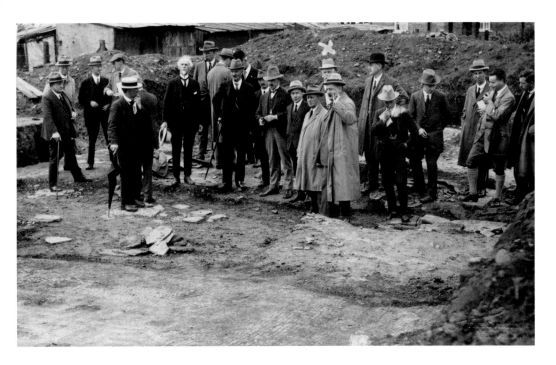

Westland Roman Villa Excavation, 1923

In 1916, a hoard of Roman coins was found near Seaton Road, together with evidence of buildings, but it was not until the Yeovil Borough Council purchased the land at Westland Road for housing that excavation was begun in 1923 and extensive Roman foundations were uncovered, together with a number of mainly fragmented mosaic pavements. The early photograph shows councillors and officials inspecting the excavations, which were subsequently covered over to preserve them, a children's play area (known by generations of local youngsters as 'Romans') was laid out, and the site is now a scheduled ancient monument.

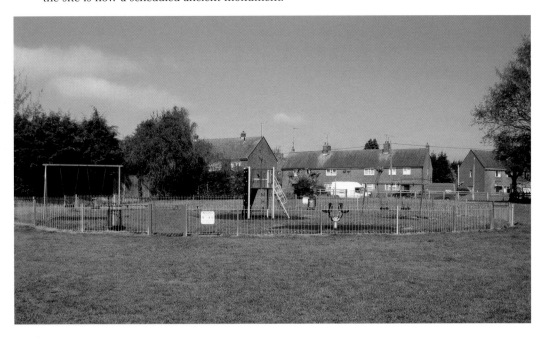

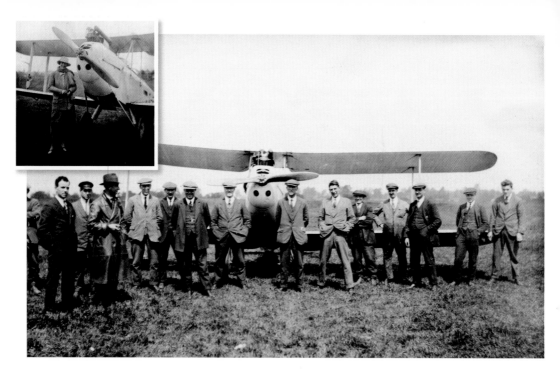

Delivering the News, May 1926

A note on the photograph taken on 5 May 1926 at Westland's airfield reads 'Members of the Westland Aircraft Co's organisation, which the day after the general strike was declared, despatched over 150,000 newspapers by air from Yeovil to every part of Southern England and Wales.' The general strike (4-12 May), had stopped the distribution of newspapers by rail. Taking part was Mrs Sophie Elliott-Lyne (inset) who had flown down from Netheravon, with a broken wrist. In 1926 Westland's main entrance was at the end of Westland Road, shown in the modern photograph.

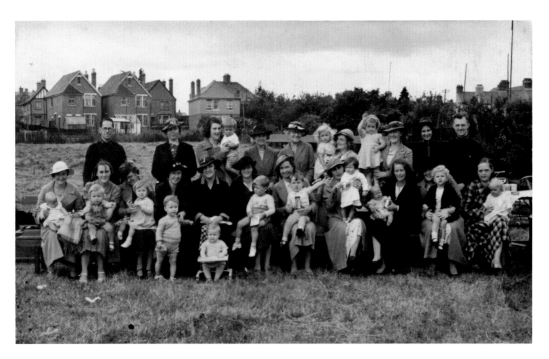

Yeovil Salvation Army 'Bonny Baby' Competition, 1937
Fourteen proud mothers smile happily for the camera at the Yeovil Salvation Army 'Bonny Baby' competition during the summer of 1937. The field in the photograph was between Grass Royal, seen to the rear, St Michael's Avenue on the right and Matthews Road. Today the field is the site of Grass Royal Junior School, seen on the right of the modern colour photograph taken from the Grass Royal Play Area.

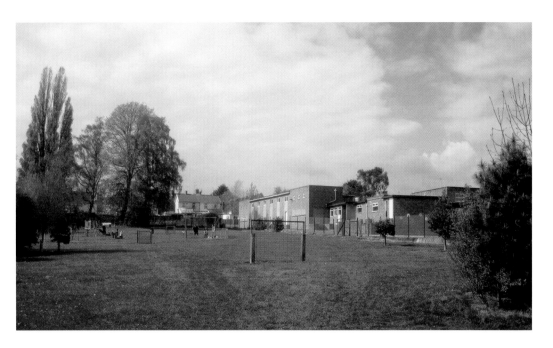

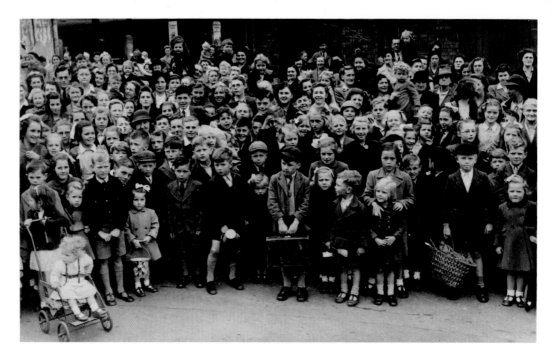

Yeovil Baptist Church Sunday School Outing, 1946

The Yeovil Baptist Church Sunday School outing to the seaside was always eagerly awaited and the first summer outing in 1946 after the end of the war was no exception. In this photograph, the excited youngsters assemble on the forecourt of Yeovil Town Station about to board the special train to take them to Weymouth. In the modern photograph, the two mature plane trees on the centre right are the sole survivors of the trees which flanked the north side of the station forecourt, now the home of Yeo Leisure Park.

chapter 7

Disasters

Lightning strike near Yeovil, 23 June 1906.

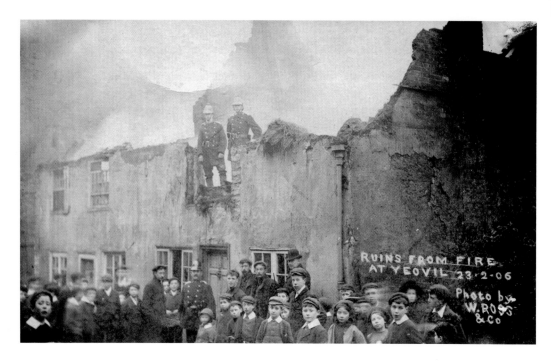

South Street Fire, 23 February 1906

The fire actually started in the back cheese store of Clement's grocery shop on High Street. Spreading rapidly at roof level, it threatened the Three Choughs Hotel on Hendford, in addition to the two ancient thatched cottages on South Street (shown here). The Yeovil Volunteer Fire Brigade (formed in 1861), commanded by Captain Edmund Damon, rushed to the scene, but unfortunately could not save the homes of the Parsons and Field families. Ironically, in 1913, the fire brigade moved in next door, when the old Cheese Market was converted into the town's first proper fire station!

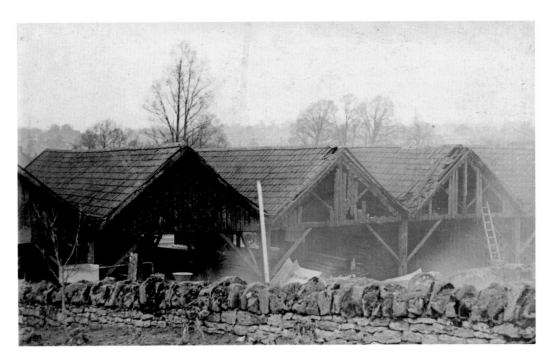

Hendford Hill Fire, 6 January 1908

Early one evening a fire broke out in a large wooden building in Bradford's yard, off Hendford Hill (a site that they still occupy). It contained a Petter oil engine, a fuel tank, grinding machines, a corn mill and a large quantity of grain. Despite the best efforts of Captain Damon and his volunteer firemen, the building and contents were lost. However, a much greater disaster was narrowly averted by their prompt action. In the adjacent Hendford Goods Yard (GWR), had been several trucks and oil tankers — fortunately the flames never got that far!

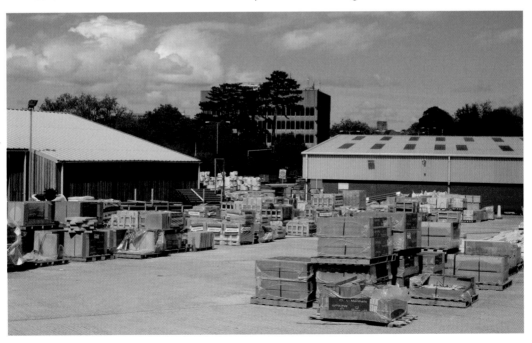

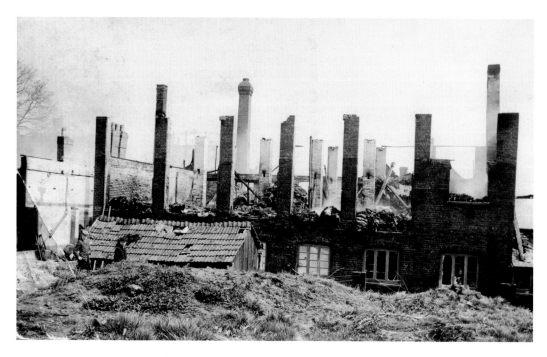

Mill Lane Fire, 23 April 1909

Clustered around the old Town Mill were Chapman's builders and decorators premises and two leather dressing yards owned by Ewens & Johnson and Ebenezer Pittard. A fire broke out at Chapman's and spread quickly, due to the highly inflammable materials stored there. Again the valiant fire brigade turned out, ably led by Second Lieutenant Frederick Cridland. Though Pittard's was saved, Ewens & Johnson's (shown here) and Chapman's were destroyed. Total damage was put at almost £10,000 and thirty men were made redundant. (See the introduction for the correspondence side of this postcard).

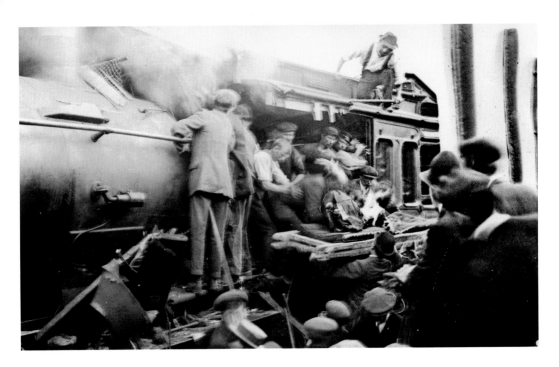

Yeovil Pen Mill Station Railway Accident, 8 August 1913

This was the only major railway accident involving loss of life to happen locally. It occurred when the Paddington-Weymouth express, headed by *City of Bath* (GWR class 4-4-0/no. 3710) smashed into a stationary train. The rear coach was crushed and compressed into a mass of splintered wood and twisted metal. Three passengers died and nine were injured. Ironically, ten years earlier the same locomotive had broken a world speed record! A less frenetic scene (at the same location), is depicted in the image of a Weymouth-bound First Great Western class 150 'Sprinter' DMU boarding passengers.

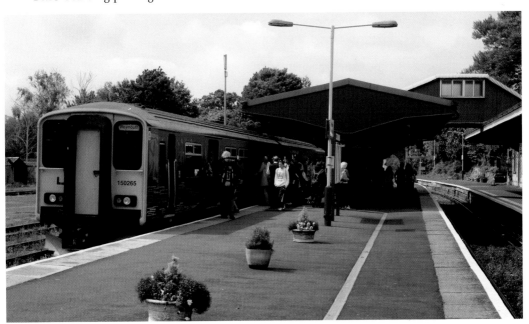

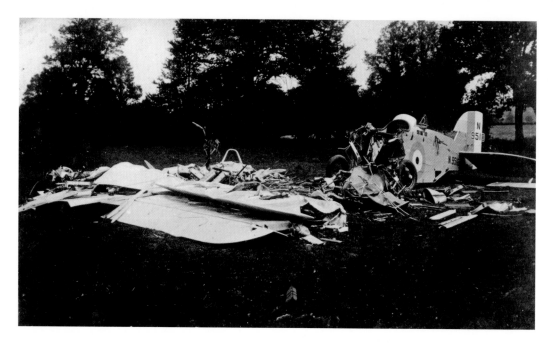

Bunford Lane Aircraft Crash, 14 June 1923

Arguably the ugliest aircraft ever to see service with the Royal Air Force, thirty-six Westland Walrus were supplied for coastal reconnaissance duties. This particular Walrus Mk II (N9510), flown by Pilot Officer James Rose, had recently undergone extensive reconditioning, including the installation of a new Napier Lion engine. Taking off westwards and climbing to about 500 feet, it banked hard left, appeared to stall, began to spin and finally nose-dived into a field. The pilot was killed in what was only the second fatal aircraft crash since Westland commenced war production in 1915. Pilot Officer Rose, RAF, lies buried in Yeovil Cemetery.

chapter 8

A Distant Prospect

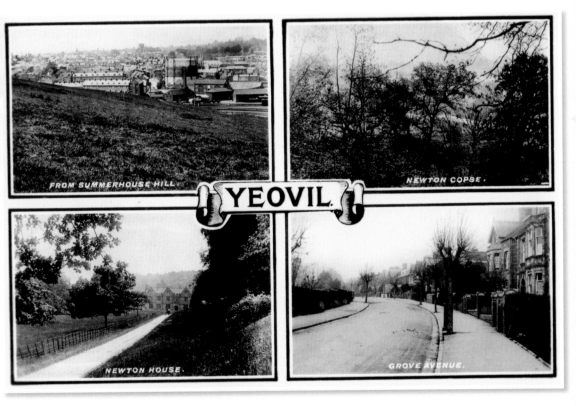

Yeovil multi-view postcard, c. 1925.

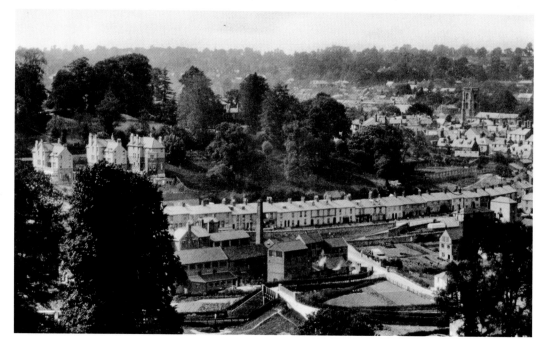

View Towards Penn Hill From Summerhouse Hill, *c.* 1920

Penn Hill was much more heavily wooded in the early years of the twentieth century than it is today. Though hidden by trees, then as now, its crest was crowned by the late eighteenth-century Hamstone Penn House — successively home to the Daniell, Neal and Bradford families. The long row of terraced houses (Park Street) bisects the older image, with the Victoria Bridge crossing over the Yeovil Town — Taunton railway line (opened 1861) prominent in the foreground. Between the two are Town Mill and several leather dressing yards — all long since gone!

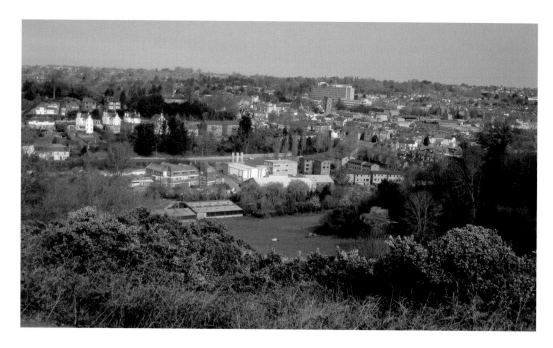

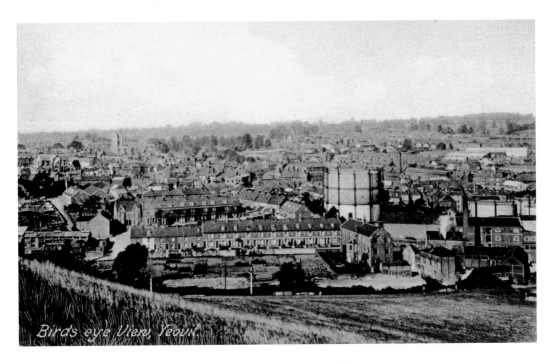

Birds eye View, Yeovil

View Towards Yeovil Gas Works From Summerhouse Hill, *c.* 1900

The rather intrusive gasometer, adjacent to the present-day Wilkinson's store, boldly marks the location of Yeovil's Gas Works. Constructed in 1833 on the site of a drained withy bed, by the middle of the nineteenth century it was illuminating 124 street lamps. Below and to the left of the gasometer stretches Summerhouse Terrace, built in 1876. The modern skyline is dominated by the looming bulk of Yeovil District Hospital (opened 1973), on Higher Kingston and the ever-present St John's church tower. Grazing cattle on the hillside above Yeo Leisure Park provide a nice visual reminder of the town's rich agricultural hinterland.

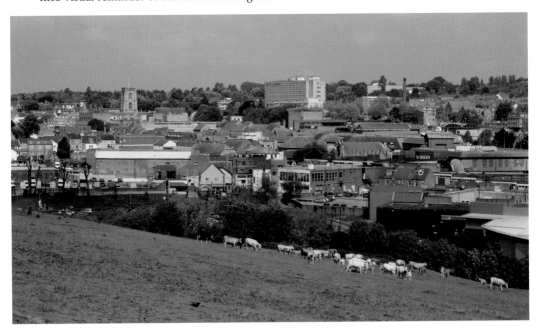

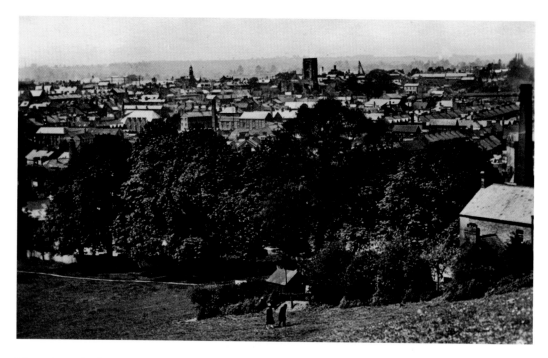

View Towards the Parish Church of St John the Baptist From Wyndham Hill, *c.* 1920
The parish church of St John the Baptist was built between 1380 and 1405. This building replaced
an earlier Saxon structure and is affectionately known as 'The Lantern of the West', due to its
profusion of large windows. In the modern image, Ivel Court flats can be seen rising above the
hedge, adjacent to the lower slopes of Wyndham Hill. This modern, low-rise development takes
its name from 'St Ivel' cheese — a household brand name that originated in 1901 in the Aplin &
Barrett creamery, formerly situated on this site.

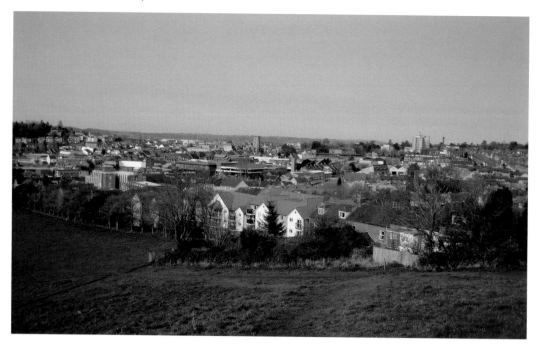

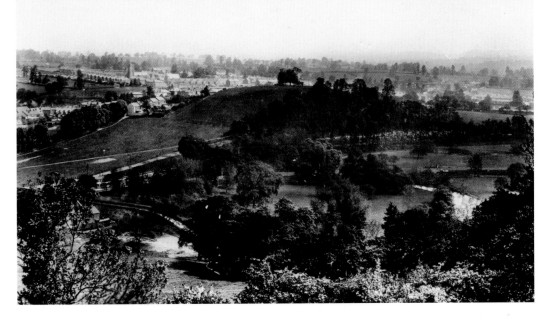

View Towards Wyndham Hill From Summerhouse Hill, *c.* 1910

The parish church of St Michael and All Angels, visible in the distance on Brickyard Lane (now St Michael's Avenue), was consecrated in 1897. Below Wyndham Hill flows the River Yeo, with the connecting line (opened in 1857) between Yeovil Town and Yeovil Pen Mill stations running in a cutting alongside. Since the line's closure in 1968, it has been converted into an attractive foot- and cycle-path within Yeovil Country Park. Wyndham Hill (named after a prominent local family) used to be known as Windmill Hill — though no trace of such a structure has ever been discovered.

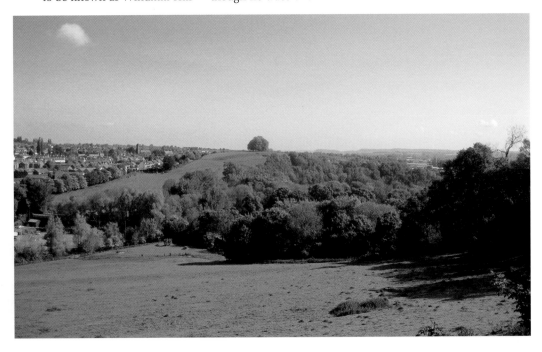

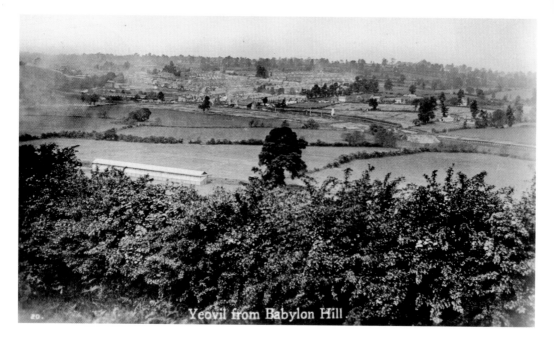

Yeovil from Babylon Hill

View Towards Lyde Road From Babylon Hill, *c.* 1920

Despite the linear residential development creeping along Compton Road (in the centre of the modern image), Yeovil's still-rural setting is well demonstrated in this final pair of images. Towards the right-hand margin of the older image, above the Yeovil Pen Mill, Westbury railway line (opened 1856), the fever isolation hospital, can be seen dimly. Constructed by Yeovil Borough Council in 1872 and accommodating only four beds (though later enlarged), it was severely hard-pressed during the diphtheria and scarlet fever epidemics of the early twentieth century. The temporary-looking wooden structures (left, above the foreground hedge), relate to the site's occasional use as the Yeovil Showground.

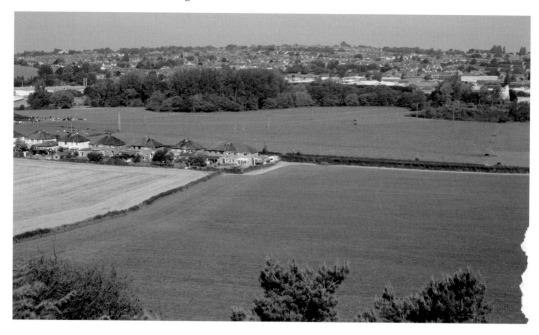